Shalom Y'all

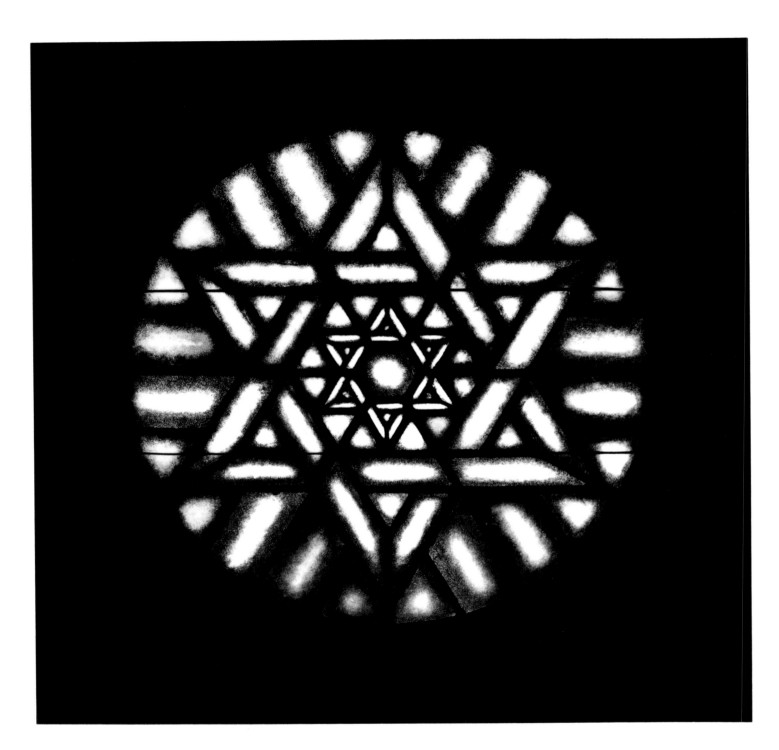

Stained Glass Window, Temple Israel. Jonesboro, Arkansas.

SHALOM Y'ALL

Images of Jewish Life in the American South

Photographs by Bill Aron

Text by Vicki Reikes Fox

Assisted by Bill Aron and Marcie Cohen Ferris

Foreword by Alfred Uhry

ALGONQUIN BOOKS OF CHAPEL HILL

2002

Also by Bill Aron

From the Corners of the Earth:
Contemporary Photographs of the Jewish World

Published by
ALGONQUIN BOOKS OF CHAPEL HILL
Post Office Box 2225
Chapel Hill, North Carolina 27515-2225

a division of
Workman Publishing
708 Broadway
New York, New York 10003

Library of Congress Cataloging-in-Publication Data
Aron, Bill.
 Shalom y'all : images of Jewish life in the American South / photographs by Bill Aron ;
story by Vicki Reikes Fox with Bill Aron and Marcie Cohen Ferris ; foreword by Alfred Uhry.
 p. cm.
 ISBN 1-56512-355-7
 1. Jews—Southern States—Pictorial works. 2. Southern States—Pictorial works. I. Fox,
Vicki Reikes. II. Ferris, Marcie Cohen. III. Title.
 F220.J5 A76 2002
 975.004'924—dc21 2002066569

10 9 8 7 6 5 4 3 2 1
First Edition

Dedicated to the Museum of the Southern Jewish Experience and its founding director, Macy B. Hart, for preserving and championing the heritage of the Southern Jewish community, and for providing vision and support throughout this project.

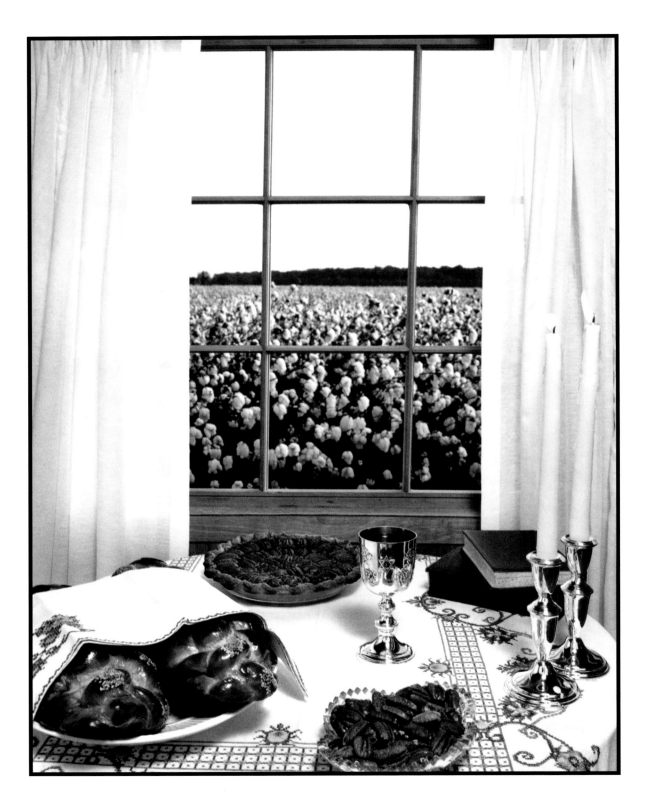

Shabbat in the
Mississippi Delta.
Cary, Mississippi.

CONTENTS

When I was a child in the forties, it was as normal as breathing to be Southern and Jewish at the same time. That's just what I was. Not that there were so many Jews in Atlanta back then. We were definitely a minority, and the tight little German Jewish community I was born into was smaller yet. There may have been observant members of our congregation (which was, and is, called simply the Temple), but my family and my friends' families weren't among them. We kids were raised with Christmas trees, Easter Egg hunts, no Hebrew school, no bar mitzvahs, no seders, no Sabbath dinners, and a very watered-down Sunday School education that left us all bored stiff. We were Jews in name only, I guess, but we were definitely Jews. I don't remember any people converting or trying to anglicize their names. The message we got was, "Keep your chin up and deal with it," sort of as if we'd been born with physical deformities.

I'm happy to report that this kind of mind-set has been pretty much eradicated. My two Atlanta nephews, for instance, who were born into the same world as I, are observant Jews today, with Shabbat services, holiday celebrations, and temple attendance. This summer, my eldest great-nephew will become a bar mitzvah, the first in our family. What happened? Well, for one thing, it became hard to maintain the kind of hangdog Judaism of my youth after the horrors of the Holocaust became known. And as racial pride emerged in the 1960s, a surge in religious identity emerged along with it. Somehow it became "cool" to explore roots and traditions. And it seems to have stayed that way. Even now I officiate at the family seder every year, though I have to call on a cousin when it comes time to read the Hebrew.

Okay, we weren't so good at the Jewish part when I was growing up, but the Southern part — ah, the Southern part! We really had that down. Baked ham with redeye gravy, fried chicken, turnip greens, grits, and gallons of sweetened ice tea were our constants. I never even heard of a bagel until I went north to college. My grandmother did make matzo balls, but she called them cracker balls whenever company came. And none of this seemed at all weird at the time. What did seem weird was Yankees. My mother's cousin Bobby married a girl from Chicago. I always got a kick out of answering the phone when she called. She sounded to me like she was talking through her nose. All my relatives were Southern, and all their relatives were Southern. There was a Jewish network in those days that stretched from Atlanta to Savannah to Mobile to Chattanooga to Hattiesburg to New Orleans to every Southern town and city on the map. Gossip and love and friendship and marriage and family occasions linked us all together. It never occurred to me that we were some sort of anomaly.

It was the Jews I came across in the movies who were the aliens. These movie Jews generally came from a never specified old country. They had thick accents. Husbands and wives called each other "mama" and "papa". These mamas and papas always had an intense son who was determined to be either a prize fighter or a violinist. If the movie was a musical, he wanted to be a songwriter or a singer. These people lived in the innermost part of the inner city. Sunlight never came anywhere near their apartments. None of them played tennis or belonged to a country club. Their lives were as far from mine as the space aliens that inhabited a whole other genre of films made during those years. Incidentally, Hollywood Southerners of the time were equally strange to me. They either lived on crumbling plantations or in shacks in the country. They didn't talk. They drawled. They called each other "honey chile." They said "y'all" when addressing one person. ("Honey chile, is y'all gonna eat the rest of that biscuit?") The guys were all rednecks and the girls were all simpering airheads.

So no wonder the rest of the country couldn't quite put together the image of a Southerner and a Jew. It was sort of like combining a chicken with a goat—peculiar and probably not possible. After I settled in New York I gradually realized how freakish I appeared. I had traditionally Jewish features, but I also had a Southern accent. Did they expect me to sound like Zero Mostel?

My friend Eli Evans, author of *The Provincials,* among other books, tells of finding the original Jew in a small North Carolina town. The man was very old. Eli asked him how come he chose to settle in this tiny rural community. The man looked at him a moment and said, "The horse died."

That story is emblematic of Jewish settlement in the Southern states. There wasn't a town without at least one Jewish family. It's a testament to their courage and determination that they stayed. They weren't black and they weren't exactly white. They were just Jews. And they did what Jews have always done—they hung on. My own great-great-grandfather came to Georgia before the Civil War. Like Eli's old Jew, he was a peddler. He eventually started a wholesale drug business. My father's side of the family settled in Louisiana. They were haberdashers in towns like Plaquemine and Lake Charles. Later generations of both families went into the retail furniture business with stores all over the South. Most Southern Jews, like my people, were merchants, but as the photographs in this book so eloquently show, they were farmers, too, and mailmen and just about everything else.

People often ask me if Southern Jews are more Southern than Jewish or the other way around. I never know how to answer. Are New York Jews more Jews than New Yorkers? Judaism is a religion, not a race. The practices of the faith intermingle with regional customs and traditions. Last names may have been Goldberg or Stein, but first names were often Betty Lou and Sister or Buddy or J.W. Notice I use the past tense. The South is changing. Last year I spoke to a large audience of junior-high school students in Marietta, Georgia. In the question and answer period that followed my talk, I

noticed that most of the kids asking questions had no trace of a Southern accent. I asked one of the teachers why there were so many Northern children in the school. She told me that these kids were Georgia-born and -raised. "They don't seem to have accents anymore. I think it's television." Whatever it is, it's too bad. Clearly there were a lot of unpalatable and unacceptable practices in the South when I grew up. Dialect wasn't one of them, however.

Before we get completely homogenized, it's good to have a record. And what a detailed and evocative record Bill Aron and Vicki Reikes Fox (assisted by Marcie Cohen Ferris) have provided here. Did you know there are towns called Felsenthal, Arkansas, and Kaplan, Louisiana? I certainly didn't. I guess I did realize that we Jews had left our mark on our native soil, but I had no idea how indelible a mark it is. I am especially fond of Aron's photograph of elderly Aaron Kline, proudly standing in his store located in Alligator, Mississippi. Mr Kline's establishment is called the Whale Store. The reason is explained in the text accompanying the photograph. I love the warmth conveyed in the picture of Rabbi Gurvis and his family celebrating Shabbat in Jackson, Mississippi. I think this healthy, joyful depiction of Southern Jewish religious life is especially poignant to me because I never had it. It's comforting to know that it was there all along, even though I missed out on it. I am also drawn to Aron's series of photographs of old Jewish cemeteries in small towns. My own ancestors are buried in such a cemetery in Plaquemine, Louisiana. I know because my sister and I paid a visit some years ago. It was moving to recognize familiar names along with unfamiliar ones and to see so much Hebrew on the headstones. Standing there, I realized I was part of a continuum that stretches back to the beginning of Southern Jewish history.

I mention only a few of the photographs and texts that accompany them, but I could go on and on. Altogether they tell a tale that is rich and, ultimately, positive.

Maybe the accents will fade, but the traditions won't. I feel sure that they'll be making chopped liver in Arkansas and baking challah in Alabama for a long time to come. Perhaps the rural synagogues will shrink away as the population shifts, but the Judaism is here to stay. As long as there's a South, there'll be Jews inhabiting it—upstanding, strong Jews like the ones who had the vision and fortitude to immigrate all those years ago.

It is indeed my honor to welcome you to the world Bill Aron and company have captured—a world I'm proud to belong to. Shalom y'all!

—**Alfred Uhry**

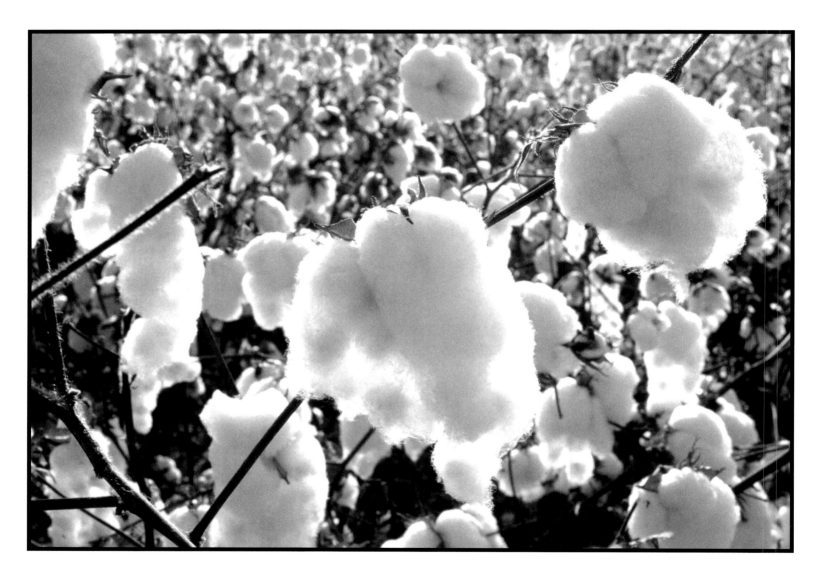

Cotton Field, Mississippi Delta. Cary, Mississippi.

Growing up in the Bible Belt, I was always aware of my dual identity as a Southerner and a Jew. Dressing up for Mardi Gras and for Purim, setting the table with magnolia blossom centerpieces and decorating the temple's sukkah, I enthusiastically embraced the richness of both cultures. Yet, whenever I traveled outside of the South, my Southern accent was heard as being at odds with my Jewish identity. Similarly, at home, synagogue services on Friday night instead of church services on Sunday morning reminded me weekly of the differences between our family and my neighbors.

Although I knew we were a tiny minority, later I would learn that Jews had lived in the South since the 1700s. Arriving mostly as peddlers from the Northeast and Europe, Jewish merchants became an important part of Southern life. Their prosperity and civic involvement helped support growth in all areas of their communities. Later arrivals and subsequent generations became involved in other enterprises: they were cotton brokers, manufacturers, scrap dealers, doctors, lawyers, and politicians. In my own hometown of Hattiesburg, Mississippi, with less than fifty Jewish families, Jewish-owned businesses were ever present; Louis Tailoring, Fine-Brothers Matison, Waldoffs on Pine, and Shemper Steel. My first job was at the Vogue, a ladies clothing store where the owner, Max Signoff, was also my Sunday School teacher.

Settling in the most church-minded section of the nation, Southern Jews started congregations, built synagogues, and bought land for cemeteries as soon as there were enough Jews in one locale. The synagogue became the center of Jewish life and celebration, which often took on a decidedly

Southern character. Even today during the Jewish harvest festival of Sukkot, communities along the Mississippi River use freshly picked cotton from nearby fields to cover their sukkah. Synagogue cookbooks combine Southern and Jewish culinary traditions of charoset with pecans, matzo ball gumbo, and lox and bagels with cheese grits. Jewish cemeteries such as the one in Natchez, Mississippi, contain tombstones of Jewish soldiers dating from the Civil War.

During the early 1970s, I was foraging through a Hattiesburg junk store when I came across a musty red velvet ark curtain haphazardly tossed into a box. How did this symbol of Jewish ritual practice end up in such a place? What happened to the Torah it once protected, the synagogue where it was housed, and the people who made up the congregation? It was as if a piece of my own heritage had been discarded, a part of the Southern Jewish legacy I somehow needed to preserve.

Yet, like many other Jews, I left my small hometown to attend college in a big Southern city and did not return. This exodus of young Jews ultimately meant the demise of small-town Southern Jewish life as I knew it, even as Jewish communities in larger Southern cities became invigorated by the growth they experienced. Without the next generation returning to the small towns, businesses such as the Fleischer Store in Shaw, Mississippi, closed, while the Dreyfus Store in Lavonia, Louisiana, kept its name but became instead a trendy eatery.

Individual Southern Jewish communities assumed the enormous responsibility of closing many small-town synagogues and transferring custody of ritual objects and records. Torah scrolls, synagogue chandeliers, eternal lights, and even an ark were brought for safekeeping to Macy B. Hart, then the director of a Jewish summer camp in Utica, Mississippi.

As more small Southern Jewish communities disbanded, Macy recognized the need for a permanent repository for their architectural and sacred Jewish objects. In 1986, because of my unique

experience as a museum professional, Jewish educator, and Southern Jew, Macy asked me to help create the Museum of the Southern Jewish Experience, which is dedicated to exploring and preserving the historical legacy of Jews of the South.

As the museum began to collect Jewish artifacts, I envisioned a contemporary photographic project to capture the images of Southern Jewish life. While I selected the personalities and places that tell the story of both the diminishing small-town populations and the vibrant larger communities, I also looked for a photographer. Although Bill Aron, renowned for his photographic images of Jewish life throughout the world, had never been to the South, he was intrigued by the project. On photographic trips, Bill quickly became attuned to the rhythms of the South, and his sensitivity and artistic eye enabled him to capture the layers of Southern Jewish life.

These photographs and stories reveal the intimacy of family relationships and the bonds between community members. In *Shalom Y'all,* fifth-generation temple members and young Orthodox families alongside football heroes, beauty queens, and cotton planters are linked together as they celebrate Jewish traditions with a Southern flavor. At religious events and family reunions, Hebrew tunes are sung with Southern accents, chopped liver is served with biscuits, and the hora and Cajun two-step are danced one after the other.

Shalom Y'all marks the fruition of a journey from the discovery of a discarded ark curtain to the preservation of the rich culture of Southern Jewish life. It is our hope that through these photographs and stories you too will share in the wonder of the Southern Jewish experience—all without the mosquitoes, humidity, or bumpy back roads.

—Vicki Reikes Fox

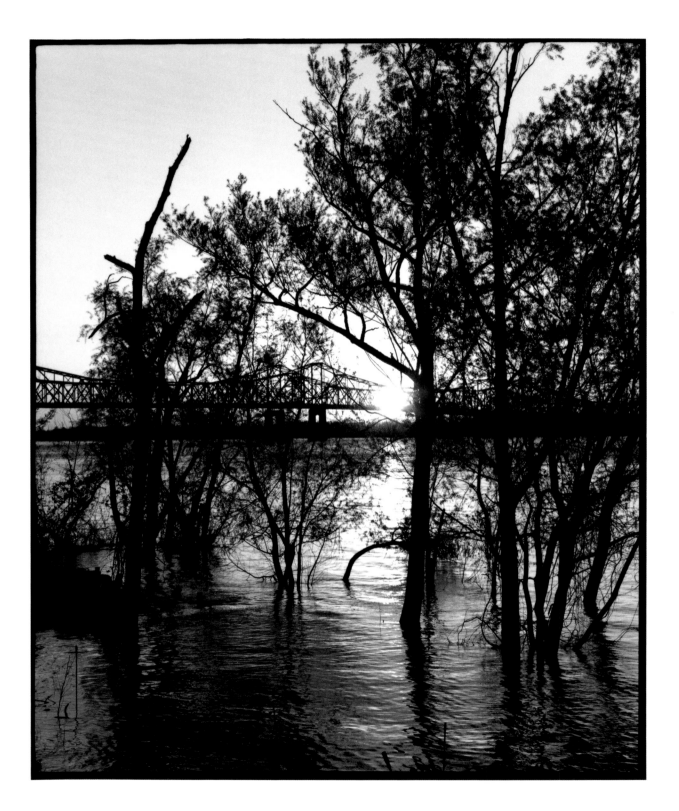

Mississippi River.

Natchez, Mississippi.

When Vicki Reikes Fox and Macy B. Hart of the Museum of the Southern Jewish Experience in Mississippi first approached me about photographing the Jewish communities of the Deep South, I thought to myself, "How hard could this be? A few trips, perhaps one per state, ought to do it." That was in 1988. I had no idea, of course, of the history and numbers of Jews in the South, let alone the distances involved.

Fourteen years and many excursions later, I have learned a great deal about what is called the Jewish South. One of the most delightful aspects of each trip was talking with Southern Jews all over Mississippi, Louisiana, Alabama, and Arkansas about how their families came to settle in the South and what it was like to grow up there. In contrast to the story of my own ancestors, who came directly to Philadelphia from Eastern Europe, is that of Jake Aronov, whose travels in the early 1900s from Kiev to Montgomery is the stuff of screenplays. Or the story of how the parents of Bob Gartenberg of Hot Springs, Arkansas, met each other makes me think that the best plans are perhaps the ones we never make. Or Joe Erber, in Greenwood, Mississippi, who said, "When I started school at Peter Rabbit Kindergarten I learned Shema Yisrael was for home and synagogue, and Our Father Who Art in Heaven was for kindergarten." It was very clear to me that without these and many other poignant stories, *Shalom Y'all* would be incomplete. Their inclusion, therefore, is intended to present an added dimension to this portrait of Jewish life in the Deep South.

I am often asked how I work and what I look for when taking a photograph. I like to put myself in a situation, make sure the lighting is appropriate, and begin working. Light and shadow, back-

grounds, the lines and the geometry of the scene are all primary considerations. Sometimes this involves my waiting, sometimes it involves my acting as a catalyst. Most important, however, are the subjects themselves and which particular instant, which fraction of a second of our interaction, gets represented. In photographic terms, I aim to capture what Henri Cartier-Bresson calls the "decisive moment," that is, the moment when a mood is best expressed, when all the elements, including facial expressions, align themselves in the most compelling geometric relationship.

All this is, of course, after-the-fact analysis. Even when I carefully plan the details of a shoot, the serendipity of the interaction between myself and the subject always dictates what happens, and rarely coincides with my expectations. It is awkward for me to write about this process in the particulars because my planning, my thoughts, and my decision making all occur only before I begin shooting, and not after.

While seeing, for instance, that shrimp importer Michael Shackleton, with a mischievous grin, has thrust two handfuls of shrimp toward me, or that Lucille Hart has leaned into her husband Harold's shoulder as they both break into laughter, or that Joe Erber and his uncle, Meyer Gelman, in response to a query from me, have straightened up in a dignified stance — while these situations are actually developing, there would not be enough time to decide whether or not to make the photograph. By the time that thought would be finished, the moment would have passed. These kinds of photographs are the product of many elements, both planned and spontaneous, some technical, some emotional, and some interactive. At its best, when it happens, it is a truly remarkable and exhilarating experience and precisely why I love what I do.

Photography, contrary to popular myth, is not a solitary enterprise, especially for a project of this length and complexity. I would especially like to acknowledge, and thank, those Southern Jews who over the years have allowed me to enter their lives and, in some cases, to invade their privacy. Not all of them appear on these pages, but all deserve my deepest appreciation. The openness of their hospitality and their cooperation kept me coming back for more as the scope of this project expanded over the years.

Finally, it would be difficult to overstate the value of one's family while involved in a project of this length and dimension. My wife, Isa, and my sons, Hillel and Jesse, gave me the encouragement and the love that sustained me throughout.

—**Bill Aron**

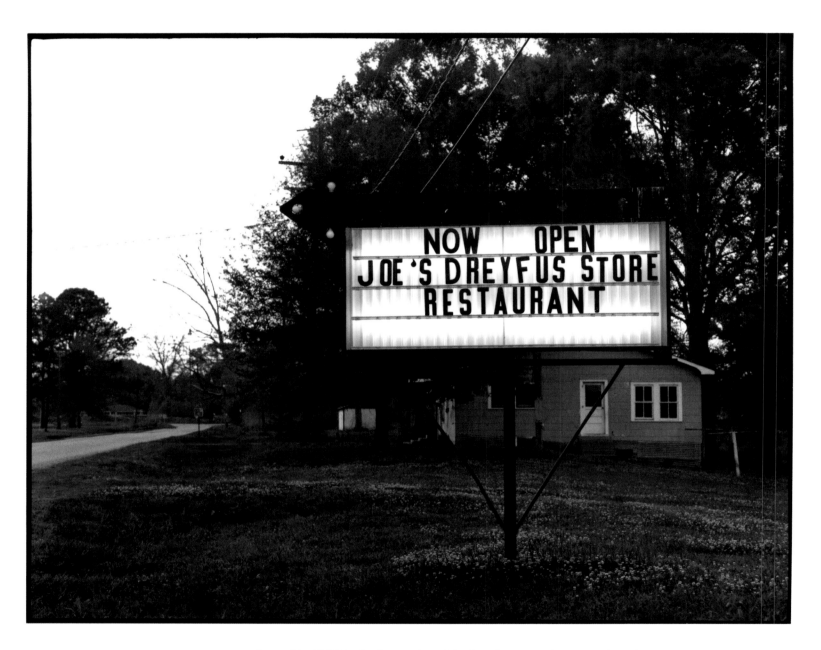

Joe's Dreyfus Store. Livonia, Louisiana. Opened in 1989 in the former site of the Dreyfus Store, the owners kept the name to symbolize the good will the store had generated for almost one hundred years.

ACKNOWLEDGMENTS

This project and this volume of photographs would never have happened without the leadership, the support, and the friendship of Macy B. Hart. Throughout the years, Macy's creative vision has not only sustained the project, but also guided it through its conceptualization, funding, execution, and conclusion.

We are grateful to Betty Lee Lamensdorf, longtime board member of the Museum of the Southern Jewish Experience, who provided encouragement throughout the duration of this project. Along with her husband, Ben Lamensdorf, and children, Louis Howard and Deborah Sue Lamensdorf Jacobs and Ike Morris and Mary Jane Lindsey Lamensdorf, she also provided generous support for the preparation of the manuscript.

When we finally called closure to the trips South and began to put the manuscript together, there were far too many images to include. Three people, in particular, shared invaluable insights during the initial editing process: Grace Grossman, curator at the Skirball Museum here in Los Angeles; Alain Labbe, one of the owners of Paris Photo Lab; and photographer Grant Mudford. Amy McFarland at the Los Angeles County Museum of Art gave generously of her time and expertise during the preparation of the manuscript.

We wish to thank Marcie Cohen Ferris, who from 1991 through 1994 organized the trips, conducted the interviews, and processed those materials. Mary Ann Jacobson at the Museum of the Southern Jewish Experience provided assistance in finding any information we needed. She always seemed to know just where to find the answers to our questions. Former museum historian, Mark Greenberg, also cheerfully aided in our research.

For additional information about the Jews of Arkansas, we turned to Carolyn LeMaster, author of the encyclopedic work, *A Corner of the Tapestry: A History of the Jewish Experience in Arkansas, 1820s–1990s.*

The following institutions and individuals provided the financial support necessary for the road trips and exhibitions: the Museum of the Southern Jewish Experience; the Jewish Welfare Fund of Mobile, Alabama; the Mississippi Committee for the Humanities; the Montgomery Friends of the Museum of the Southern Jewish Experience; the National Council of Jewish Women, New Orleans Section; the Ottenheimer Brothers Foundation, Little Rock, Arkansas; the Rotenstreich Family; Sam Eichold; and Mr. James L. Loeb. Thanks are also due to Samy's Camera, Paris Photo, and Photo Impact, all of Los Angeles.

The South Carolina photographs in this volume were shot during a whirlwind two-week trip in October 2000. Project director Dale Rosengarten provided entrée to a statewide network of Jewish South Carolinians developed during years of fieldwork. Producer Sheila Rodin-Novak held us to an ambitious schedule. John Reynolds was tireless and inventive as photographic assistant, lighting director, and all-around problem solver. Chef Heather Webb kept us healthy and energized. The College of Charleston Libraries, the McKissick Museum at the University of South Carolina, and the Jewish Historical Society of South Carolina sponsored the project, with generous financial support from the Maurice Amado Foundation, Benedict Rosen, Ron and Anne Krancer, the Jerry and Anita Zucker Family Foundation, the William Price Fund of the Spartanburg County Foundation, the Joseph J. Miller Foundation, the Barnet Family Foundation, Robert and Nancy Lyon, and the National Endowment for the Humanities. Most important, we would like to acknowledge and thank Rebekkah Farber for introducing us to the South Carolina Jewish community and to Dale Rosengarten.

Steven A. Fox, Esq., of Davis, Fox, and Berke, L.L.P., also gave advice, guidance, and invaluable counsel.

Finally, we would also like to thank our editor, Kathy Pories, and the designer, Anne Winslow, both of whom patiently sifted through the images and all the words to give the book its final form.

—Bill Aron and Vicki Reikes Fox

Shalom Y'all

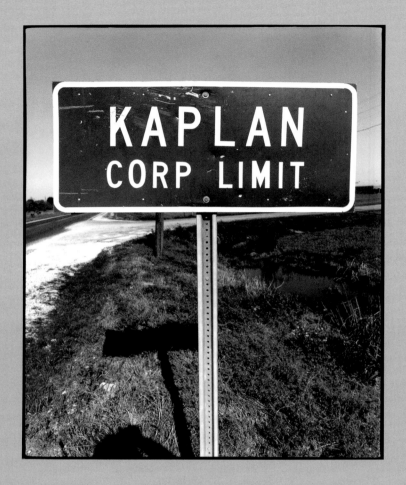

Kaplan, Louisiana. Abrom Kaplan came to St. Vermillion Parish in southern Louisiana in 1850 and began buying marshland for twelve cents an acre, which he drained, planted, and turned into rice fields. The Kaplan family then started the Kaplan and Liberty Rice Mills. As their business became profitable, they built schools, roads, and a hospital and founded the *Kaplan Herald* newspaper. In gratitude, St. Vermillion Parish was renamed.

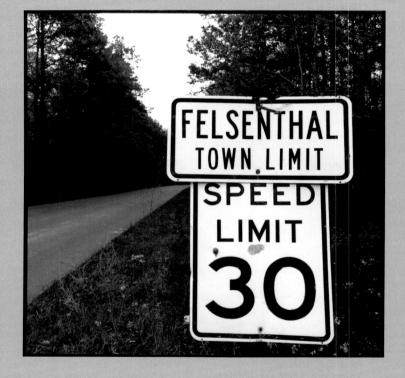

Felsenthal, Arkansas. Felsenthal once boasted a bank, opera house, post office, three hotels, a brick company, and two newspapers. The brothers Adolph, Isaac, Sidney, and Lee established the Felsenthal Land and Timber Company in south Union County around 1900, but yearly floods kept the town from becoming the industrial model community they had envisioned. It is now a fishing and wildlife preserve.

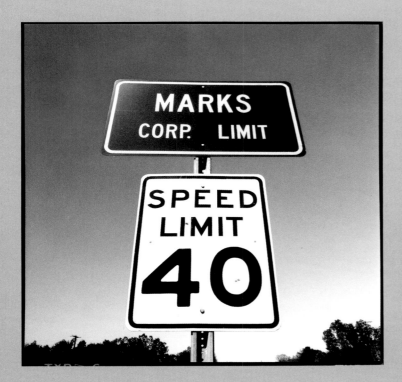

"We lived our whole lives and raised our children in a small town. We commuted to the synagogue in Baton Rouge—about sixty miles away—for all the Jewish holidays and most weekends. Our children grew up in a very non-Jewish assimilated atmosphere. Both of our sons married non-Jews who later converted."

SIMON AND ROSE WIEL
Former Owners of Joe's Dreyfus Store, Livonia, Louisiana

Marks, Mississippi. Leopold Marks settled in the Coldwater River region and began trading and buying land. He formed the Marks Townsite Company and received a land grant, which in turn encouraged the Yazoo and Mississippi Valley Railroad to come to the area. He also served as Quitman County's first representative to the state legislature.

Road Trip

"We have always been accepted here. Years ago, the only places that we couldn't get into were the garden clubs. Everything's changed now."

BETTY GOLDSTEIN
Greenville, Mississippi

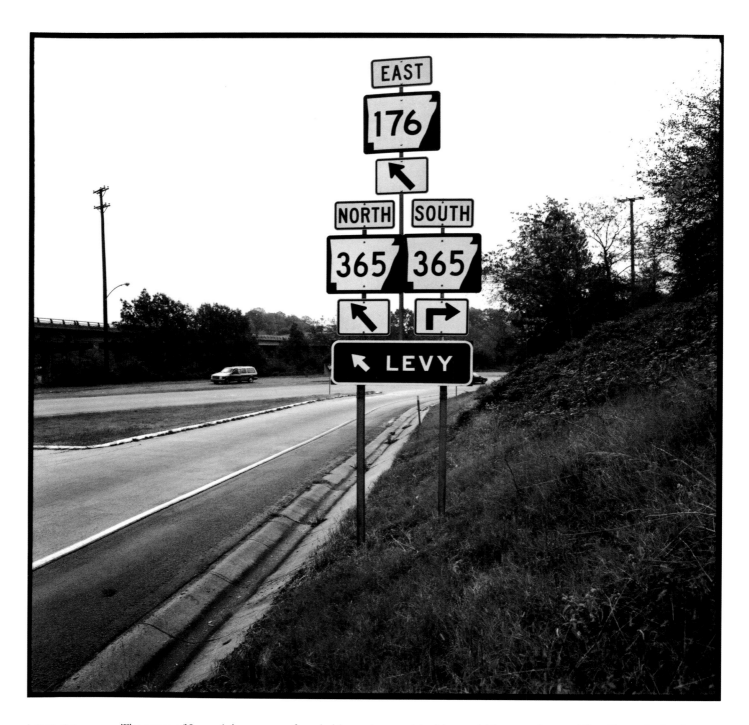

Levy, Arkansas. The town of Levy, Arkansas, was founded by an impoverished but ambitious produce peddler, Ernest L. Stanley. He named the town Levy after Morris Levy, a kindhearted Jewish merchant, who had loaned him fifty dollars to get started. Stanley used the funds to purchase a little wayside grocery store, around which the town eventually grew.

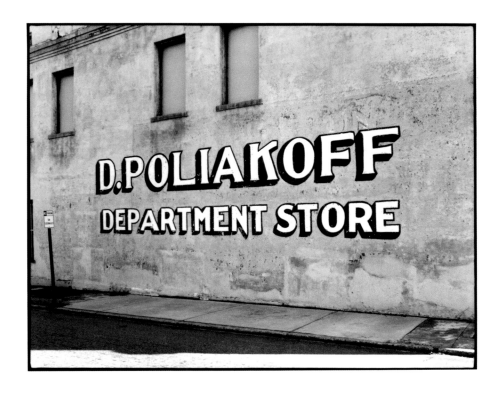

Poliakoff Department Store. Abbeville, South Carolina. Established in 1900 by David Poliakoff, an immigrant from Russia, the store closed in August 2000 after operating for a hundred years.

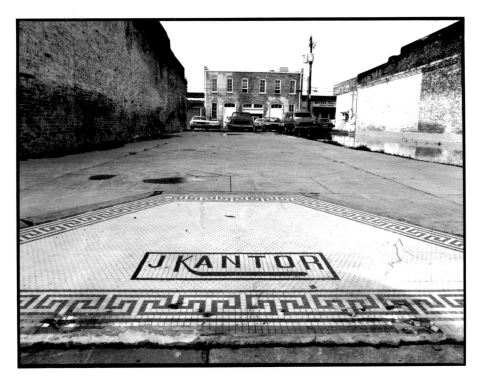

J. Kantor Store Tiles. Greenwood, Mississippi. Only signs remain from a street once lined with Jewish-owned stores and businesses. Jacob Kantor, a Russian Jew, opened a men's clothing store in Greenwood in 1896. The store was one of the first in the state to carry Hart Schaffner and Marx clothing. After Jacob's death in 1944, his son, Sol, successfully ran the business until his move to California in the 1980s. "Jacob," Sol's wife says, "was a honey of a man, the sweetest person you ever knew. He was really a daddy to everyone."

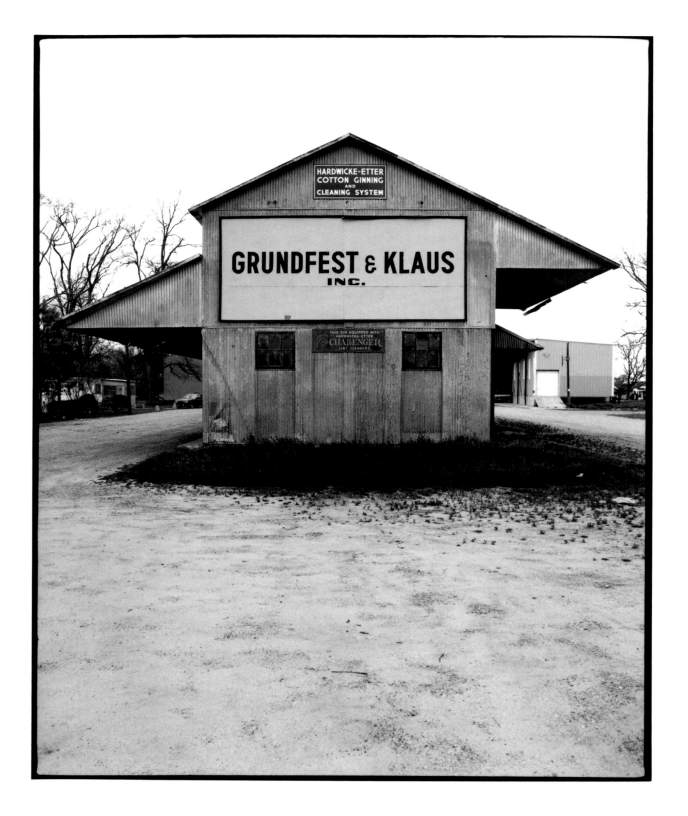

Grundfest and Klaus. Cary, Mississippi. Two brothers-in-law originally formed a partnership to create this cotton gin. Grundfest's granddaughter and great-grandson are still involved in the business.

"When I got to New York, some people from Hebrew Immigrant Aid Society met me, because I couldn't speak English, and put me on the train to St. Louis. In St. Louis, somebody met me and put me on a train to Little Rock. In Little Rock, I had a cousin who met me at a train and I had an aunt who lived in England, Arkansas, who could speak Polish or Yiddish, so I stayed with them for about six or eight months. Then my uncle in Dumas said he wanted me to come there and work for him. And I started with him."

HARRY PHILLIPS, Dumas, Arkansas

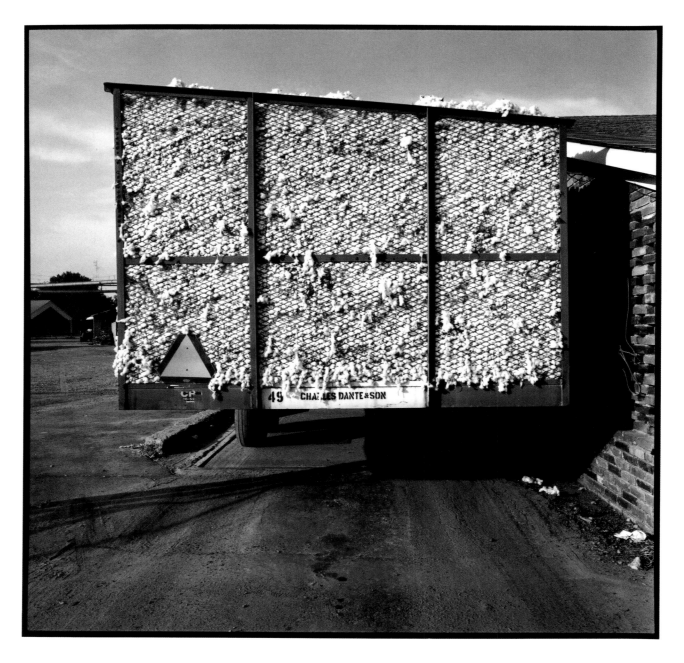

Cotton Loaded for Ginning, Dante and Son. Dumas, Arkansas. In the 1890s Charles Dante came to the United States from Poland with his brothers. He was almost penniless and began his career peddling matches and novelty items throughout south Arkansas. He opened a small store in Dumas and eventually became a major builder and developer in southeast Arkansas. As he prospered he became involved in the town's charitable civic activities, serving as mayor, president of the school board, president of the Chamber of Commerce, and chairman of Dumas Water and Light Commission, to cite but a few of his activities. Charles Dante's civic commitment was continued by his family.

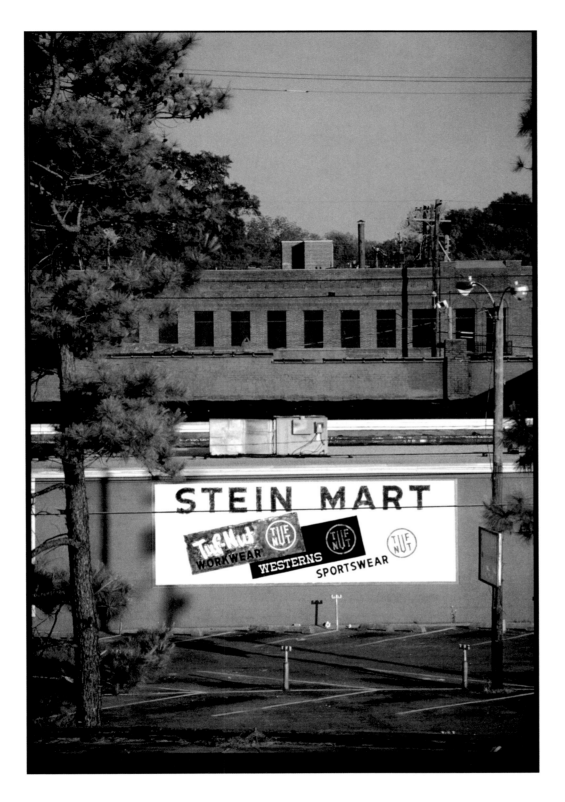

Stein Mart. Greenville, Mississippi.
Sam Stein arrived in Greenville, Mississippi, early in the twentieth century. He began his career as a peddler, traveling across the countryside selling goods door-to-door, but soon opened a store that grew to encompass an entire city block. Today there are over two hundred Stein Mart locations throughout the United States. Jay Stein, the third consecutive Stein to run the business, says of his grandfather Sam, "It is a typical story. He saw the bustling economy of the Mississippi Delta as an open door to opportunity, and he made the most of it."

Cultural Crossovers, Beth Israel Congregation. Jackson, Mississippi. The influence of Jewish culture in the South takes shape in the bagel, once a rare delicacy in Mississippi. Melissa Samuels likes hers plain, but bagels with lox and a side of grits are a regional favorite.

"[My daughter] Judy attended a nursery school with a Christian orientation.
At dinner one evening, [my son] Baruch said to Judy, 'You can't eat yet,
you haven't made *hamotzi* [the blessing over bread].' Judy answered,
'I don't want to do it.' Baruch said, 'God won't like you.' And Judy replied,
'Jesus will love me.'"

RABBI WOLLI KAELTER
Rabbi of Congregation House of Israel, Hot Springs, Arkansas, 1945–49
Excerpted from his book, *From Danzig: An American Rabbi's Journey*
Written with Gordon Cohn

Lox, Bagels, and Grits

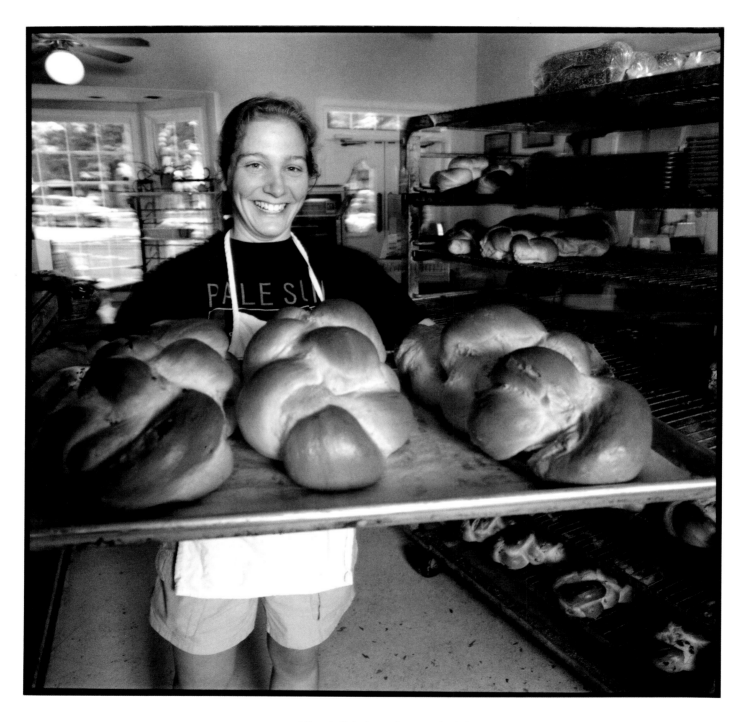

Big Sky Bread Company. Birmingham, Alabama. The challah from the Big Sky bakery is in such demand that it is necessary to place your order by Thursday if you want some for Shabbat.

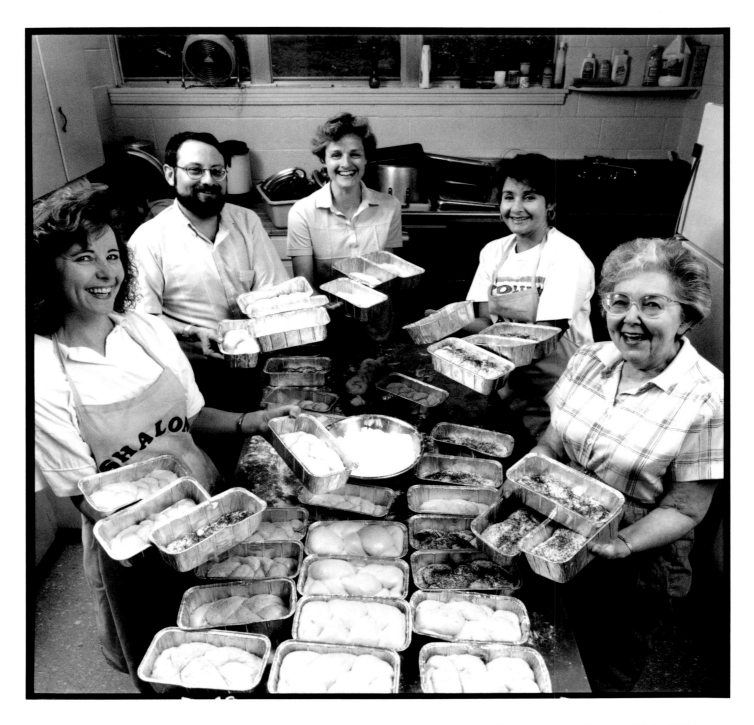

House of Israel Challah Bake Sale. Hot Springs, Arkansas. Sisterhood members, Mary Klompus, Betty Kleinman, Elaine Wolden, and Olivia Silverman, joined by Rabbi Matt Friedman, prepare over one hundred challahs, seven hundred cheese blintzes, LOTS of *rugelach*, cheesecakes, and much more for their annual community bake sale. They always sell out.

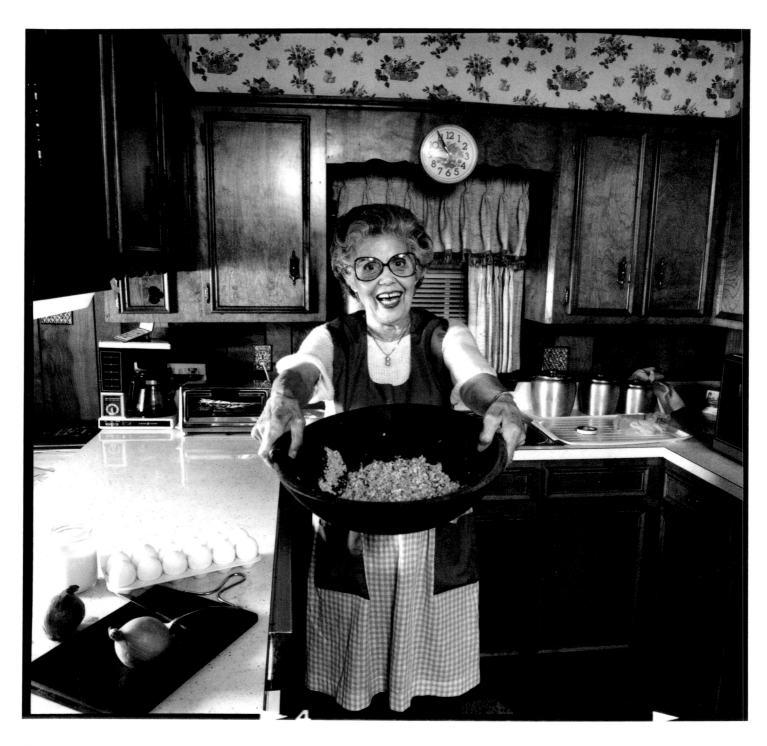

Henrietta Levine's Kitchen. Pine Bluff, Arkansas.

"You want from the very beginning? I put my livers in a little Wesson Oil and chop up onion and let them cook until the onion gets brown. I cook six to eight eggs until they are hard. Then I put chopped-up onion in the bowl with the eggs and the livers and then I add the chicken fat. I cut up a lot of onions and add a little salt and let it cook real slow and it will finally render out. It is a pretty color, because it has so much onion in it. A little more salt and that is it!"

HENRIETTA LEVINE, Pine Bluff, Arkansas

"We have our kosher meat shipped from Memphis. But some of the Jews in Memphis, they don't trust their butcher so they have their meat shipped from Atlanta."

ILSA GOLDBERG, Greenwood, Mississippi

"If I had known how much people were going to like my *schnecken* I wouldn't have had to sell shoes."

DELORES LOEB, Mobile, Alabama

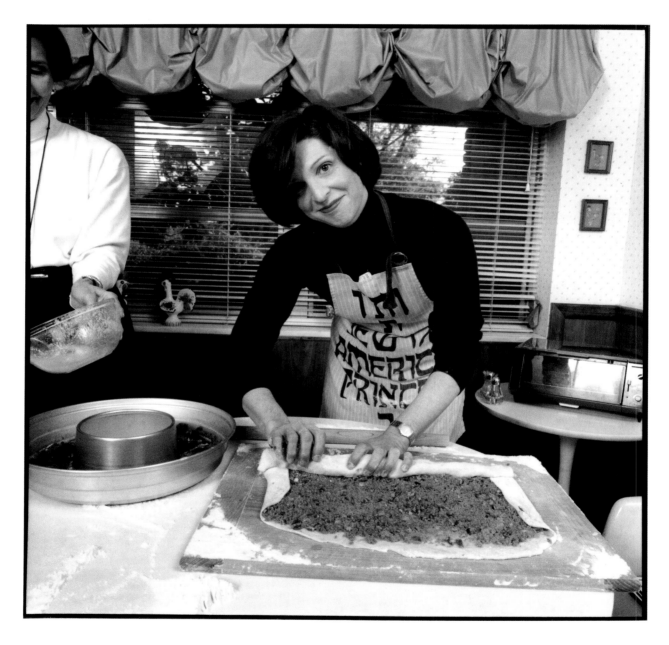

Making *Schnecken*. Mobile, Alabama. Leslie Miller and her mother, Delores Loeb, are renowned throughout the Jewish community of Mobile for their delicious *schnecken*.

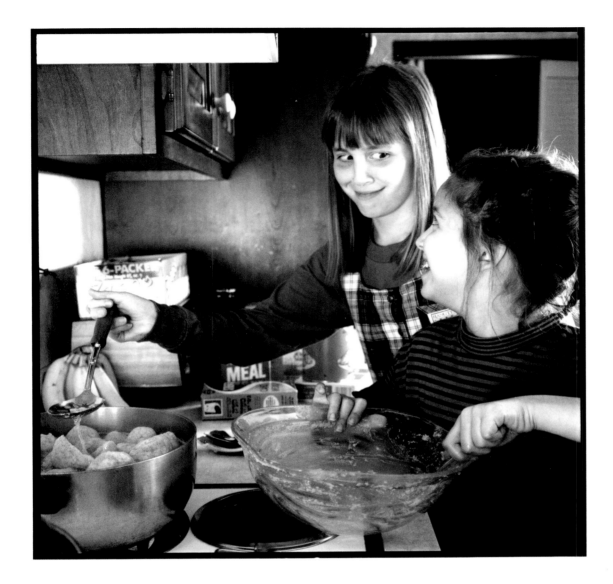

**The Dorfman Kitchen.
Long Beach, Mississippi.**
Andrea and Michelle prepare
matzo balls for Passover.
The family is part of the small
Jewish community along the
Mississippi Gulf Coast.

"The Sunday afternoon before the bar mitzvah, an older woman from Vincennes delivered
the [warm, sugared] pecans to use for the Oneg Shabbat and hospitality room. The smell
of those pecans brought back so many emotions. I remember I was alone in the house and
I put them on the counter and wept—not because I was sad, but because I was so grateful
for the gift that called up so many childhood memories of sitting on my grandmother's
back porch in Marks [Mississippi] shelling pecans."

CAROLYN LIPSON-WALKER, Southern folklorist

15

"I was the 'delivery boy.' I went to Memphis and took everybody's order and brought back the meats and the perishable foods. The matzo, the flour, the potato starch, and all that, we would ship by bus or by train because we couldn't put it all in a car. Don't you remember the wonderful smoked goose legs that we got from Cincinnati!?"

BESS SELIGMAN, Boca Raton, Florida, formerly of Shaw, Mississippi

Bagel Break,
Agudath Israel.
Montgomery, Alabama.
Bagels and cream cheese
are served during a
religious-school break
even in Alabama.

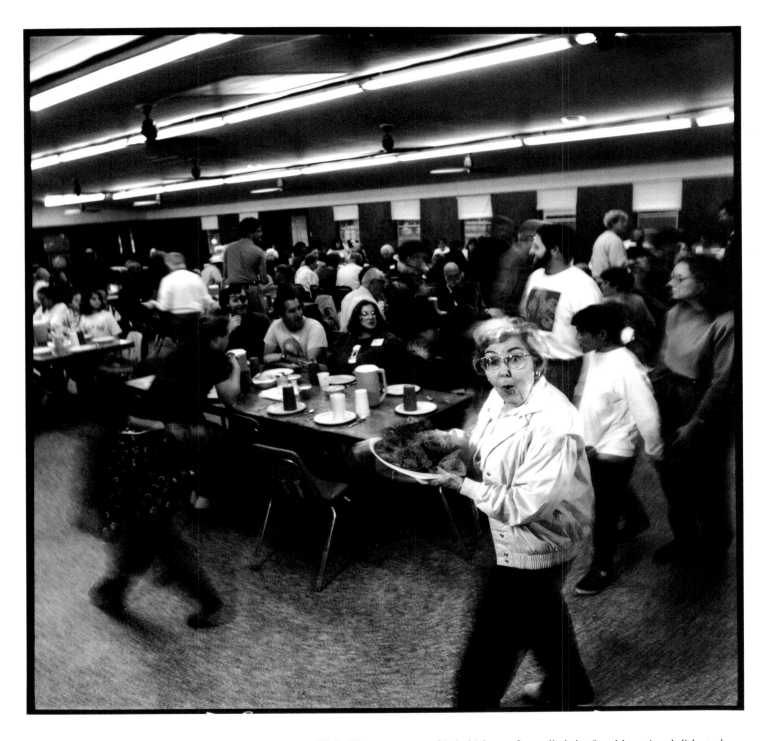

Henry S. Jacobs Camp Retreat. Utica, Mississippi. Olivia Silverman serves fried chicken, often called the South's national dish, to her table on Erev Shabbat.

On crayfish fettuccine: "When we go over to see Mama, I'll tell her to heat some up. If you haven't eaten that, you just haven't lived. It is like going to heaven and coming back."

CONNIE KAPLAN, Great-nephew of Abrom Kaplan. Kaplan, Louisiana

Jeanette Capouya. Montgomery, Alabama. Originally from Rhodes, Jeanette Capouya carries on many of her family's Greek traditions through the Sephardic food she prepares.

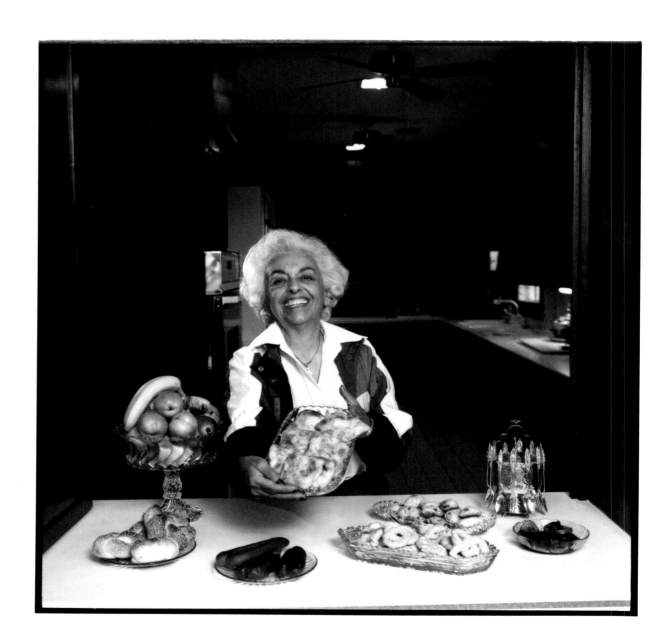

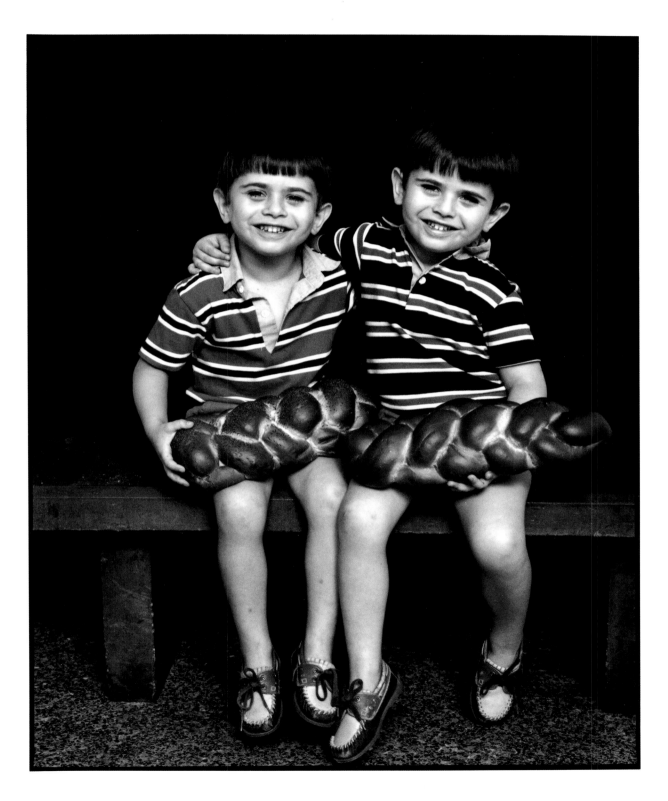

Jewish Community Center Nursery School. New Orleans, Louisiana. Located on St. Charles Avenue, the Jewish Community Center plays a significant role in the lives of New Orleans's Jewish community. The twins, age five, immigrated from Russia at the age of three.

"For years all you could hear was grits and fried eggs and things like that.
Now, whoever heard of lox and bagels? Bagels, they didn't know what bagels were."

SARAH SHUMARIA, Montgomery, Alabama

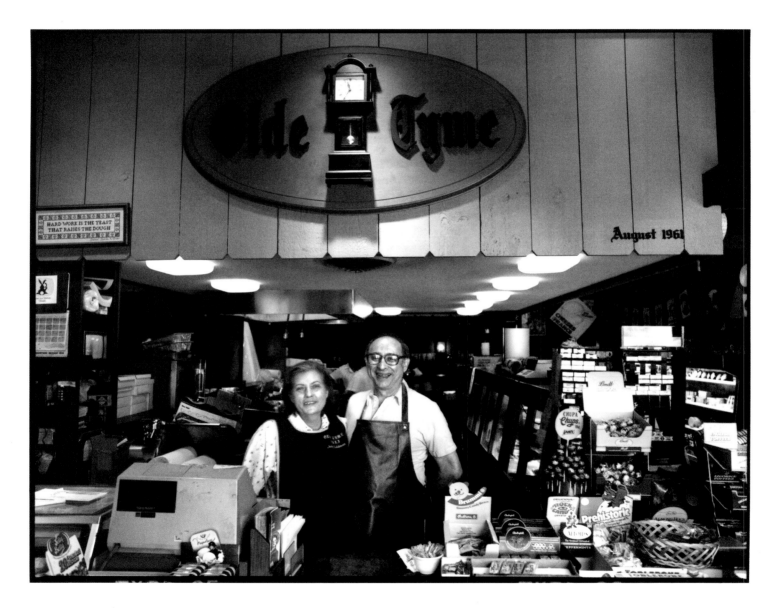

Judy and Irv Feldman, Olde Tyme Deli. Jackson, Mississippi. The Feldmans brought many Jewish food delicacies to Jackson and its surrounding communities. Southerners drive to Jackson from all over the area to stock up on food from the Olde Tyme Deli.

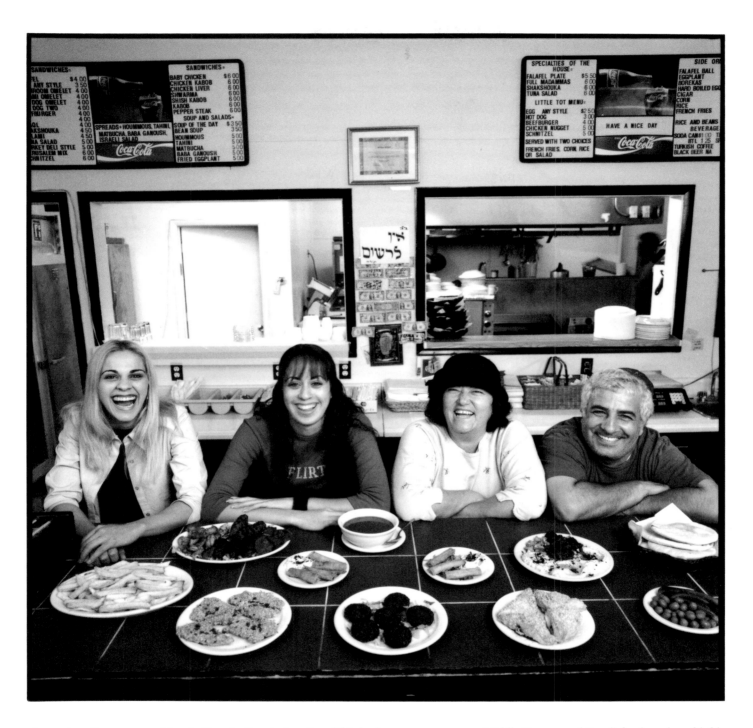

Jerusalem Restaurant. Myrtle Beach, South Carolina. This kosher restaurant serves Middle Eastern and Israeli foods such as felafel and humus. It is a gathering place for Israelis, Syrians, and others who operate many of the local surf and beachwear shops in this ocean-side community.

"My first seder was with the Weinsteins and I fixed everything. Grandma Weinstein even taught me how to make gefilte fish. . . . My matzo balls were so hard, because I didn't know that you didn't just continue to roll them and make them real smooth. They ate them, but they were tough!"

BETTY GREEN, Describing learning to "cook Jewish." Little Rock, Arkansas

Little Rock, Arkansas.
As the former chief cook at Temple Israel, Betty Green has overseen preparations for the community Passover seder for the last eighteen years. She learned to "cook Jewish" from Mrs. Eugene Weinstein and developed her challah recipe "by taste and feel." Braiding challah, she explained, was just like "plaiting hair, and I've done that all my life."

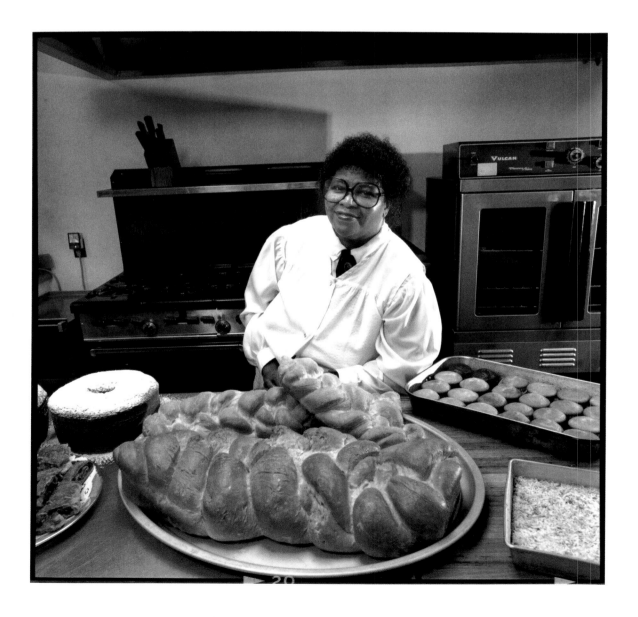

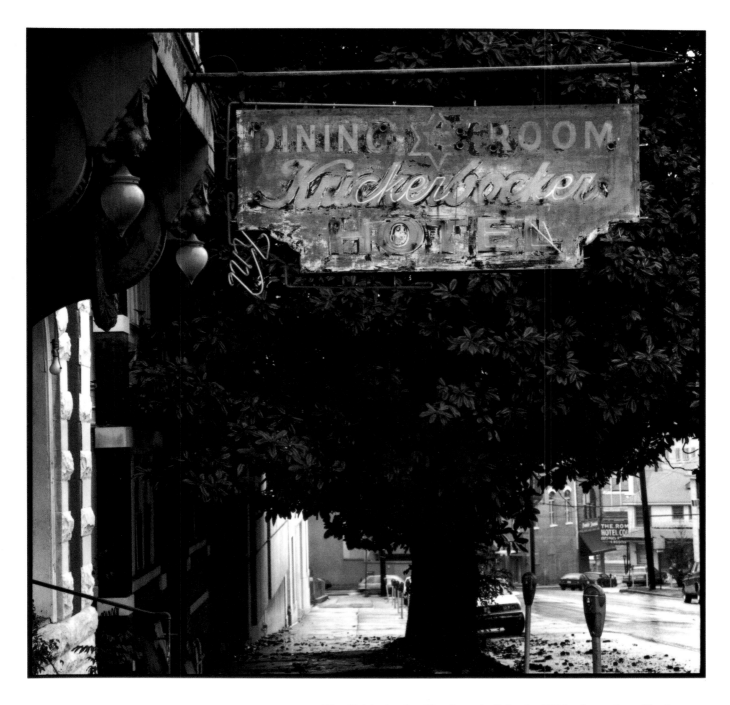

Knickerbocker Dining Room. Hot Springs, Arkansas. The Knickerbocker Hotel was built in the 1920s. A number of kosher hotels and dining rooms such as the Knickerbocker, the Balfour, and the Central catered to Jewish tourists beginning in the 1890s and lasting through the 1950s. Competition from other "spa" cities as well as the discovery of medicine to help with arthritis eventually reduced the number of people who sought out the city's restorative hot waters.

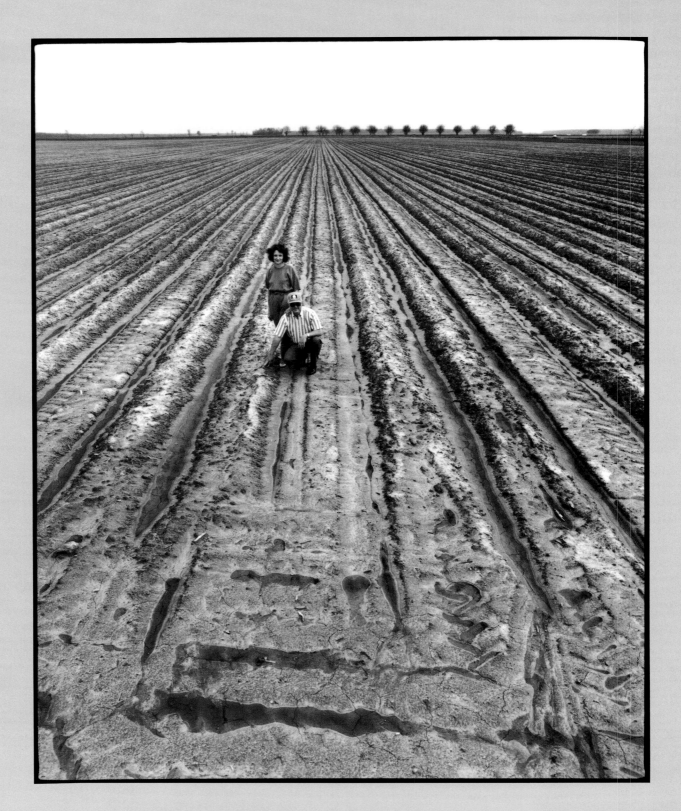

Ben and Betty Lee Lamensdorf. Cary, Mississippi. The Lamensdorfs grow cotton, wheat, and pecans in the rich Mississippi Delta farmland. Betty Lee's Russian grandfather, Morris Grundfest, who began as a peddler and later became a prosperous merchant, purchased the first Delta farmland owned by the family.

"One evening, the day Sandy Koufax announced that he wouldn't pitch in the World Series on Yom Kippur, some workers on my father's farm knocked on the door and asked him: 'You're Jewish, can you talk to Sandy Koufax about this and convince him that it is all right to play?'"

BEN LAMENSDORF, Cary, Mississippi

"My family believed in land because it made them realize they were not in the ghetto. They were part of the civilization of America."

BARBARA EDISEN, Morgan City, Louisiana

Peddlers, Planters, and Politicians

"We used to do it all. We used to sell everything from mandolins to caskets

to groceries, as well as dry goods."

I.A. KAMIEN, Cleveland, Mississippi

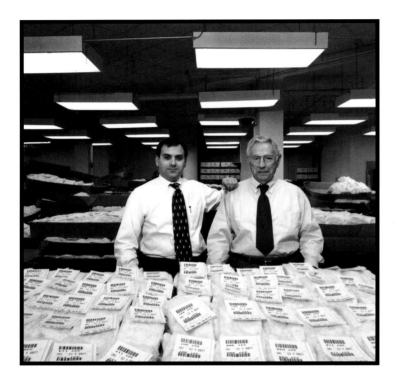

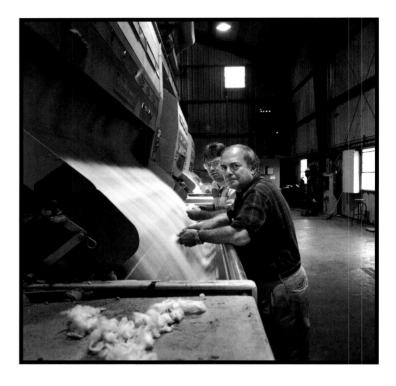

James Loeb and Son, Cotton Merchants. Montgomery, Alabama. Southern Jews have been involved in the cotton industry as long as they have been in the South. James founded Loeb and Company in 1967 and was joined by his son, James, Jr., after he completed college.

Sam and Sammy Angel at the Epstein Gin. Lake Village, Arkansas. Sam Epstein came to south Arkansas in 1900 and slept on the counter of his small Lake Village store at night. As he prospered, he purchased over ten thousand acres of land, laying the groundwork for today's Epstein Land and Gin Company. Sam Epstein Angel, his grandson, says, "He came down the river on a river boat. He was broke and just got off here. I guess he opened up a store or a couple of stores. Then he started buying land." Today Sam and his son, Sammy, oversee the operation at Epstein's Land and Gin Company.

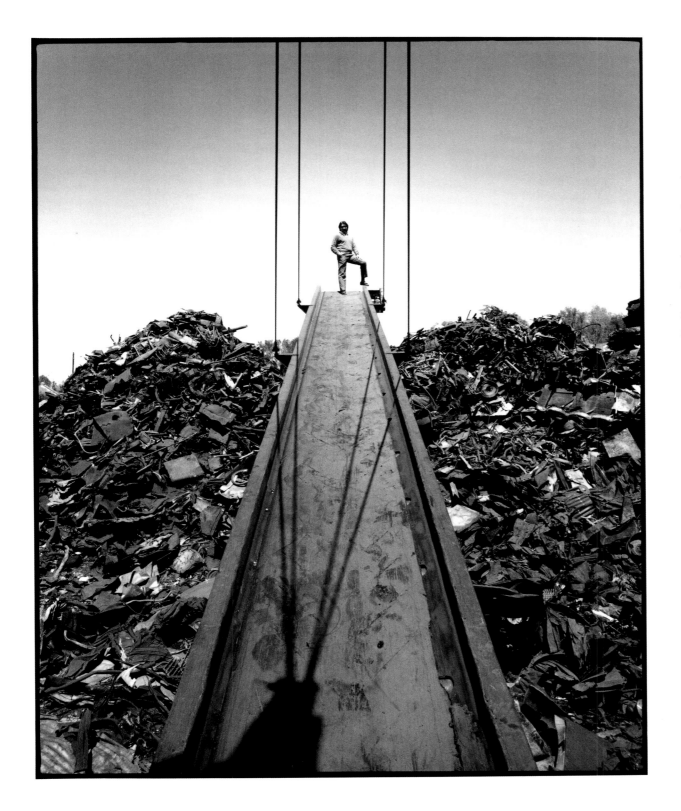

"You know, in this country you can be worth ten cents, and two years later be a multimillionaire."

MANNIE KROUSE
Natchez, Mississippi

Jerry Krouse, Krouse and Company. Natchez, Mississippi. Krouse and Company is composed of Natchez Pecan Shelling Company and Krouse Metals, both part of significant industries that have been in the South for hundreds of years.

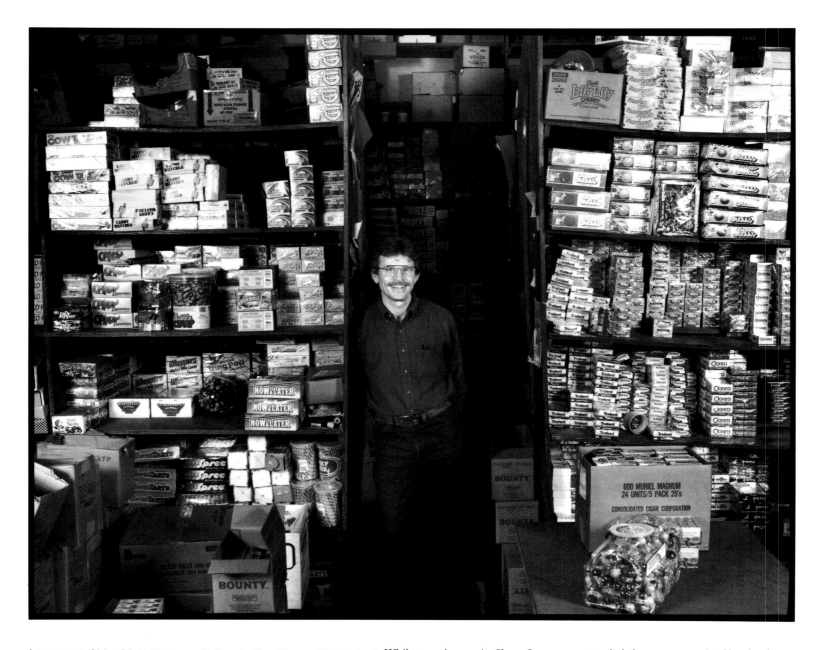

Lawrence Chiz, Dixie Tobacco & Candy Co. Shaw, Mississippi. While growing up in Shaw, Lawrence attended the synagogue in Cleveland, which once had the "largest Sunday School in the state of Mississippi." After the army, he returned to Shaw and joined the family business. About growing up Jewish in Mississippi, Lawrence recalls, "It was a unique experience. Every town along the Delta had Jews in it. But nine out of ten of my contemporaries did not come back. I am a remnant."

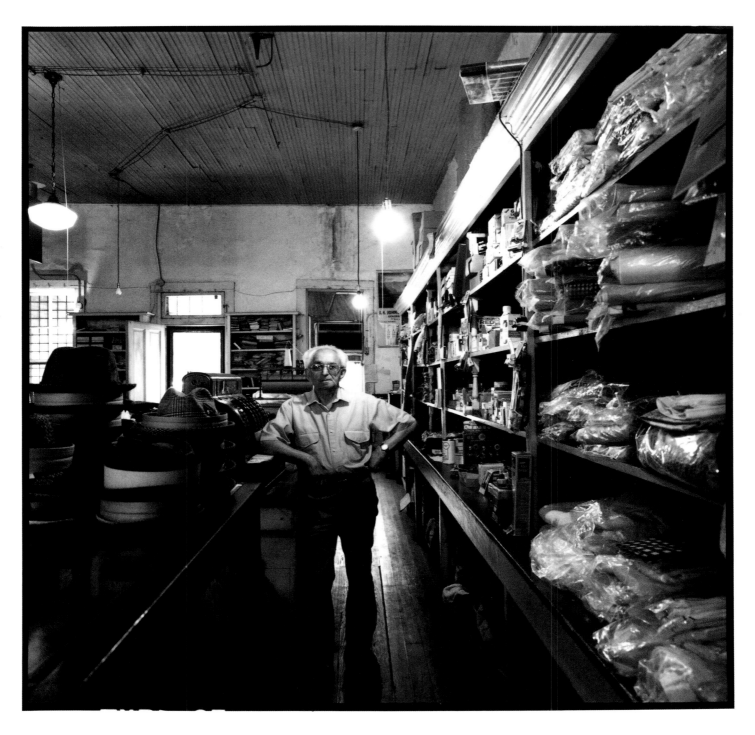

Aaron Kline, The Whale Store. Alligator, Mississippi. Aaron Kline is the last Jewish store owner in this small Delta crossroads near Clarksdale. Ask him why his business is called the Whale Store and he replies, "A whale of a store, a hell of a place!"

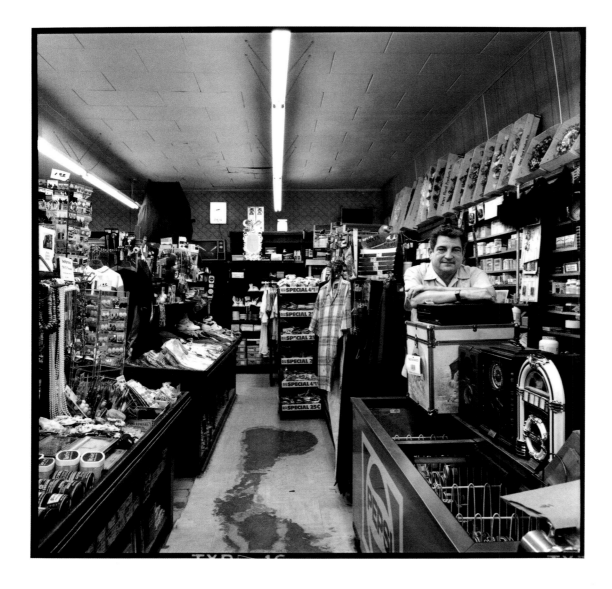

Robert Hirshberg, Hirshberg's Drug Store. Friar's Point, Mississippi. Bob Hirshberg remembers Saturday nights when one couldn't walk down the street because of the crowds. Hirshberg's Drug Store and soda fountain is one of the last businesses in this small river landing near Clarksdale, Mississippi.

"Let me tell you what it was like on Saturday nights. Next door was a grocery store and there was the huge pot-bellied stove and on Saturday nights they were so busy selling the crop. People had some money and they gathered in there to nurse their babies around this big pot-bellied stove and it was just so different from anything I had ever seen. But it was okay. We stayed open on Saturday night in the fall during the cotton harvest until people would stop coming in and that might be midnight. It was very exhilarating."

NOAH AND GERRY BARKOVITZ, Hayti, Missouri

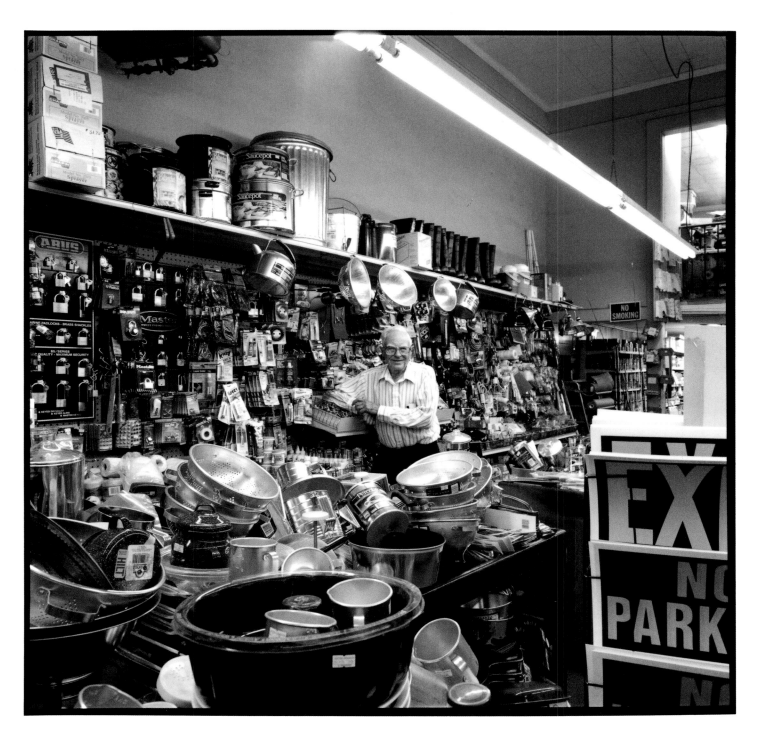

Boston Hardware and Locksmith. Selma, Alabama. Billy Rosenberg is one of the last of a large number of Jewish business owners whose department stores and dry-goods firms once lined the streets of downtown Selma.

"We still have a lady customer who has a thimble that Dad gave her seventy-six years ago when she was ten years old. She liked it so much that Dad gave it to her. She still carries it in her purse."

NOAH AND GERRY BARKOVITZ, Speaking about their store, which was founded by Noah's father in 1915. Hayti, Missouri

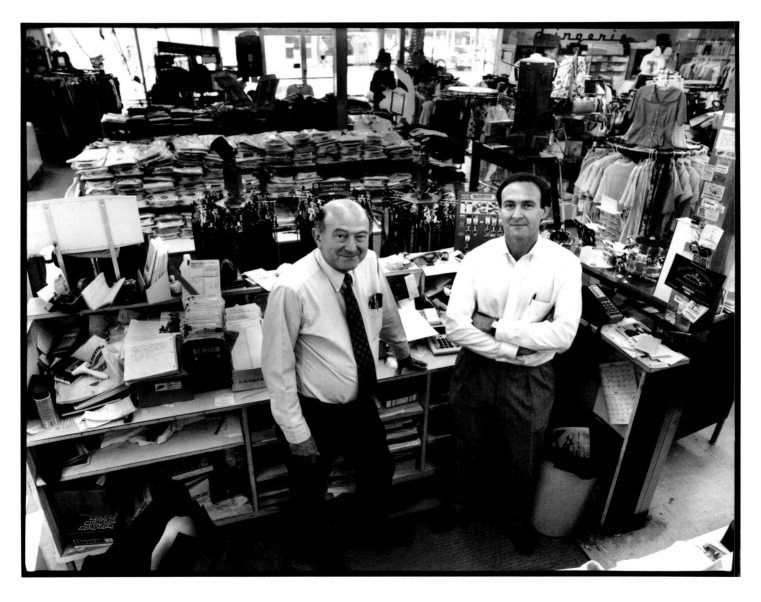

Joe Goldberg and Son Charlie, Goldberg's Department Store. Belzoni, Mississippi. Many Jews opened stores in small towns after peddling their way through the back roads of the rural South, bringing much-needed merchandise to the scattered population. Goldberg's still operates in downtown Belzoni.

"Before my daddy married he was working in a shoe store.

He used to see the KKK parades and he could recognize the men by the shoes

he had sold them. He could see their shoes under the sheets."

DOTTY LONDON STETELMAN, Hattiesburg, Mississippi

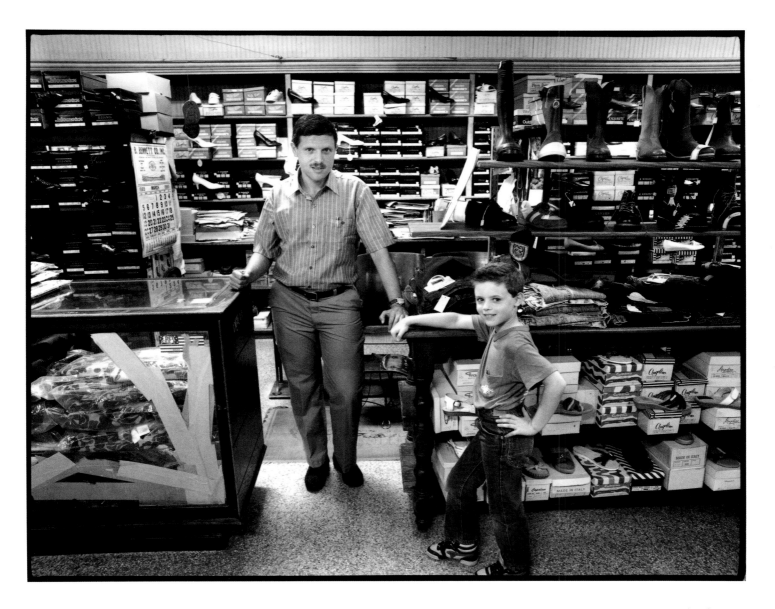

Henry Friedman and Son at Friedman and Sons. Franklin, Louisiana. On the main street in Franklin, this store is now run by the second- and third-generation owners.

"You don't have to know a whole lot about tradition in order to get to heaven.

Just live right."

HAROLD HART, Eudora, Arkansas

We met Harold Hart in his liquor store. After talking for a while, he mentioned his wife of some thirty-five years. When I asked where she was, he replied, "But she's not Jewish." After we assured him that we wanted to include her, he called her at home and asked her to meet us at the store. Harold mentioned that they had been married by Rabbi Sam Stone in Greenwood, Mississippi. I said, "Impossible. Rabbi Stone was an Orthodox rabbi and as such would not perform an intermarriage." Harold replied that they had a marriage certificate to prove it.

We went to their house to find the certificate. After a while, Harold brought out a large manila envelope and said, "It's in here." While pulling out the marriage certificate, which was indeed signed by Rabbi Sam Stone, a folded-up piece of stationery fell out of the envelope. I began reading: "Lucille . . . has come before me and the house of Israel this day and has freely consented to join the people of Israel." Without thinking, I said, "Lucille, you're Jewish." She hesitated for a split second, then asked, "Can I be buried in a Jewish cemetery?" I replied, "Of course, according to this, you are Jewish." After only a brief hesitation, she said, "Wonderful," and laughing, hugged Harold.

Apparently, this is what happened: Before their wedding ceremony, Rabbi Stone asked Lucille a number of questions about the Bible. Having had a good Christian upbringing, she answered them all at length. Afterward, he turned to Harold and said, "Harold, if you knew as much about the Bible as this young woman you are marrying, you would be a good Jew." He then asked Lucille if she would voluntarily accompany Harold to synagogue. She answered that she had every intention of doing so. Rabbi Stone then performed the ceremony.

As I understand Jewish law, there are several requirements involved in conversion. Two of these are: (1) that he or she be "Jewishly" knowledgeable, and (2) that the convert be converting of his or her own free will. Lucille apparently fulfilled these two requirements in Rabbi Stone's eyes, which was sufficient for him to consider Lucille a convert.

BILL ARON

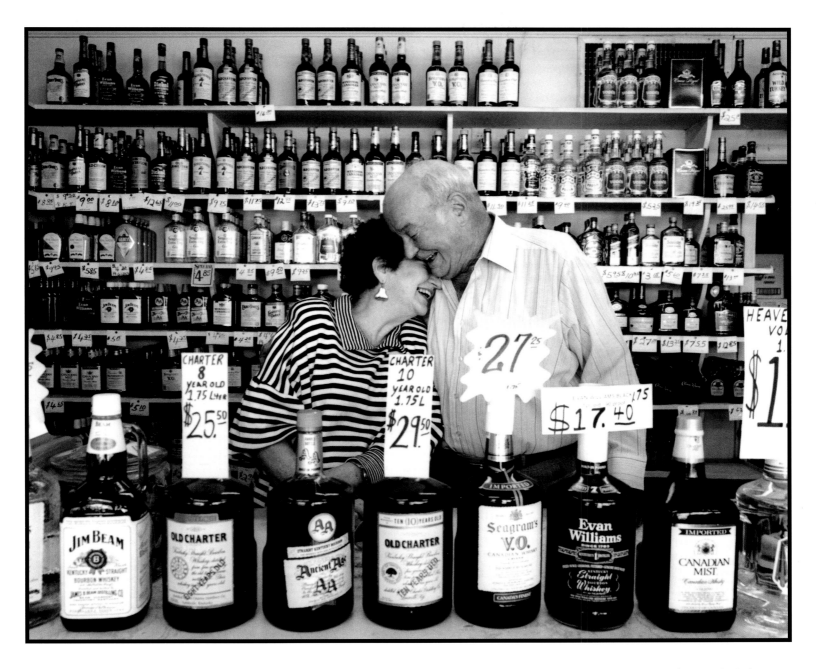

Harold and Lucille Hart, Liquor Store. Eudora, Arkansas. Now the last Jews in Eudora, the Harts were married in Greenwood, Mississippi. At one time there were so many Jewish merchants in Eudora that the Jewish community jokingly called the town "Jewdora." By the 1980s, however, they had all moved away. Harold had served on the Eudora city council and had been president of the Chamber of Commerce while Lucille had been city recorder, city clerk, and a member of the local school board.

"There is stuff in here from the thirties and forties that was never marked down. I mean so much stuff here. He [Grandfather Fleischer] was the type of man who never threw a thing away. We found pictures of our great-great-grandfather. It's unreal. There are purchase orders from 1930!"

YOUNG FLEISCHER COUSIN who came back to help Mrs. Fleischer close out the family store. Shaw, Mississippi

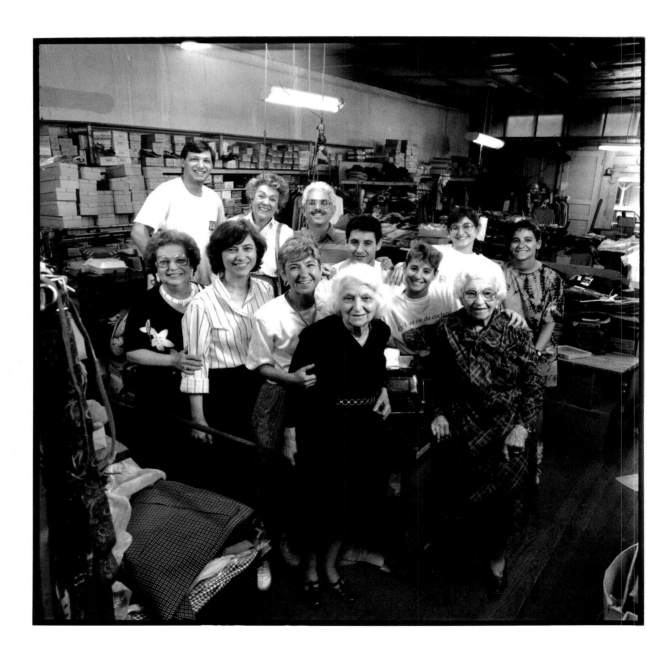

Fleischer Store. Shaw, Mississippi. Following her husband's death, Goldie Fleischer's family helped her close the family's dry-goods store, the last Jewish landmark on a street once lined with Jewish-owned businesses.

"We close up for the High Holy Days, because that is the way my mother and dad always did."

LOUISE WEISMAN LEVI, Dermott, Arkansas

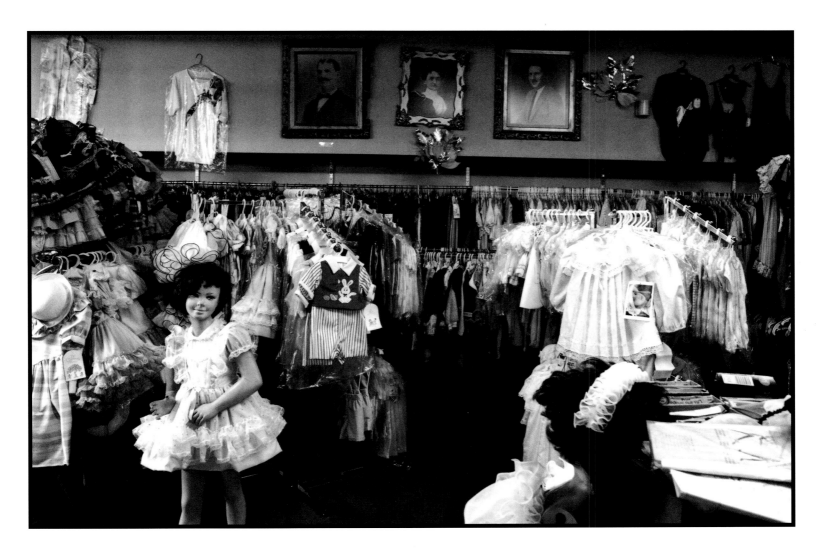

Leo Kahn Store. Morgan City, Louisiana. In the changing community of Morgan City, the Kahn Store is stocked with a large variety of merchandise from the present and the past.

"In 1898, a Jewish acquaintance of my grandfather's walks into the store and says to him, 'You're not married; would you like to be?' My grandfather says, 'Who would marry me? I am just getting started and don't have very much. Look around.' The other man says, 'I have a sister. Here, let me show you a picture. This is Carrie, isn't she beautiful?' Indeed she was very beautiful, so my grandfather says, 'Okay.' They travel to New Orleans and the man introduces my grandfather to Carrie. 'This is not the woman in the picture,' my grandfather says. 'No, this is her sister. The woman in the picture is Lena, who is married and lives in Shreveport. Would you like to marry Carrie? She is single and available.' My grandfather thinks, 'Well I have no other prospects and I did come all the way to New Orleans.' He says, 'Okay,' and they marry, have three children, and are very happy. I think it worked out very good."

ROBERT GARTENBERG, Hot Springs, Arkansas

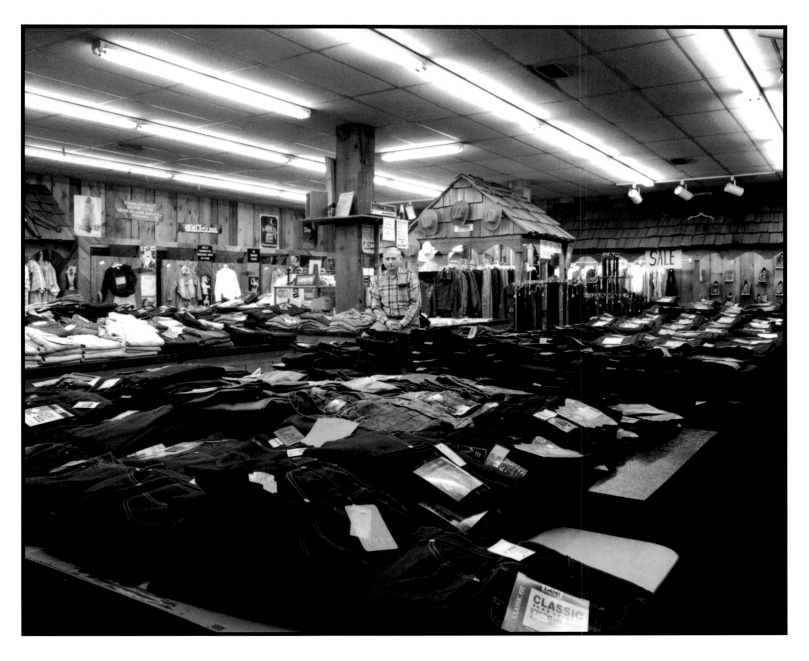

Robert Gartenberg, Gartenbergs. Hot Springs, Arkansas. Bob Gartenberg's grandfather, Peter Gartenberg, came to Hot Springs from Austria-Hungary in 1892 via New York and San Francisco. On his way back to New York he and his cousin passed through Hot Springs. "It was the first place I felt good," he said. While his cousin returned to New York, Peter settled in Hot Springs. In 1892 he opened a general merchandise store with clothing and "mis-made" shoes. He bought unmatched shoes in bulk and set them up around the store for his customers to find a best possible match. "People didn't have very much money then and the shoes were very inexpensive," says Bob. Bob's father, Leo, joined and expanded the business after World War I. In 1951 Bob joined his father, and sometime in the 1960s, he began to specialize in blue jeans.

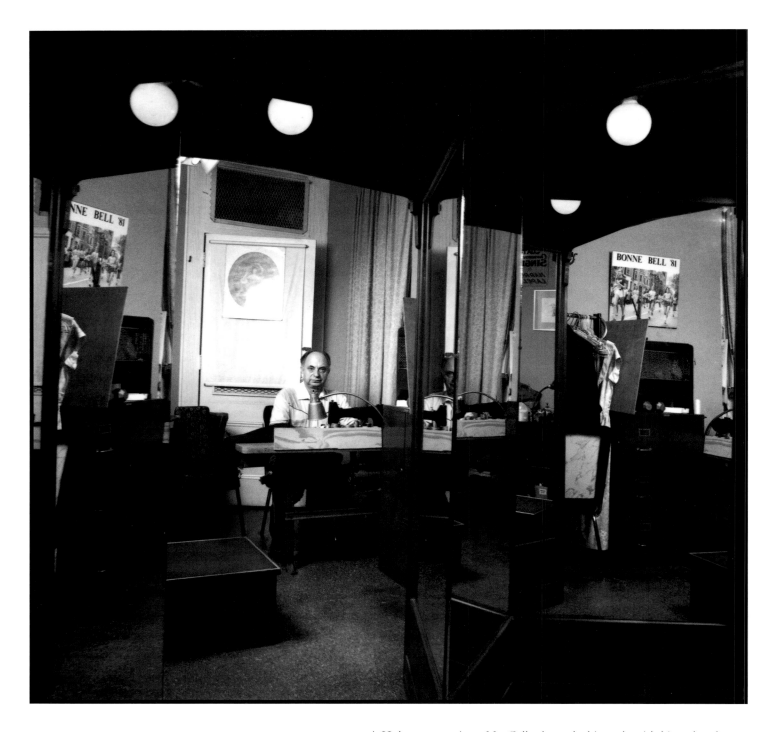

Henry Galler, Mr. Henry's Tailoring. New Orleans, Louisiana. A Holocaust survivor, Mr. Galler brought his trade with him when he immigrated to the United States from Europe. "Mr. Henry" and his wife sometimes lecture to high school students about the Holocaust.

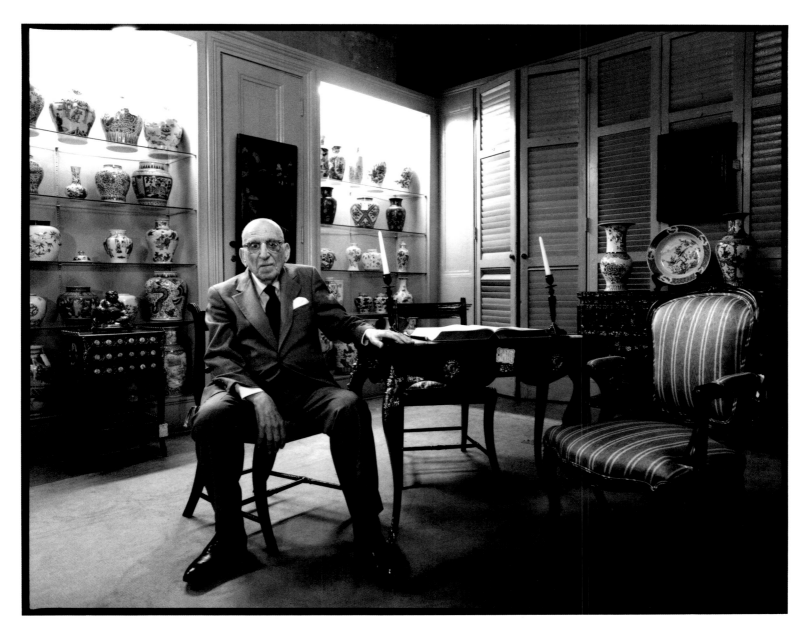

Henry Stern, Henry Stern Antiques. New Orleans, Louisiana. On Royal Street in the center of the Historic French Quarter, this antique store is a destination for locals and tourists alike. At ninety-one years of age, Mr. Stern was still active in his business. He died a few years after this photograph was taken.

"My grandfather had a shoe store and manufactured shoes. He volunteered for the Confederate Army and they wouldn't take him. Said they needed him more as a cobbler to make shoes than they needed him to fight. They could get people to fight, but they didn't have anybody else to make shoes."

MORTIMER COHEN, Montgomery, Alabama

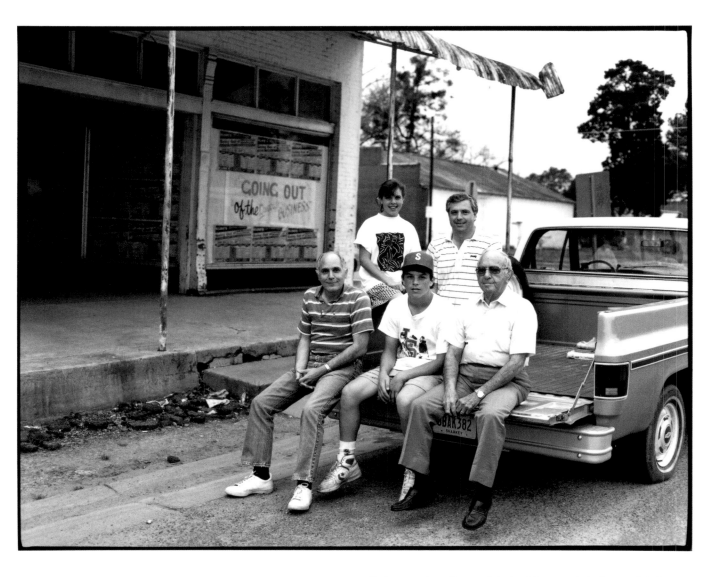

Members of the Kline and Miller Families. Anguilla, Mississippi. Sitting on the tailgate of their pickup truck in front of their closing business, the family looks out at the center of a changing downtown Anguilla.

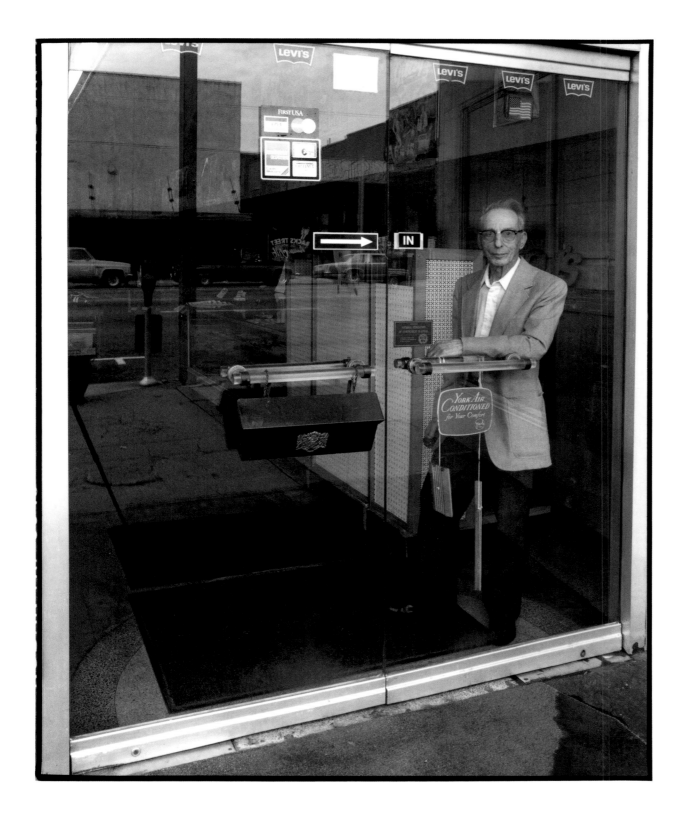

Mr. Vic. Fort Smith, Arkansas. His downtown store fell victim to the trend begun by Wal-Mart, which pushed retail centers to the outskirts of town.

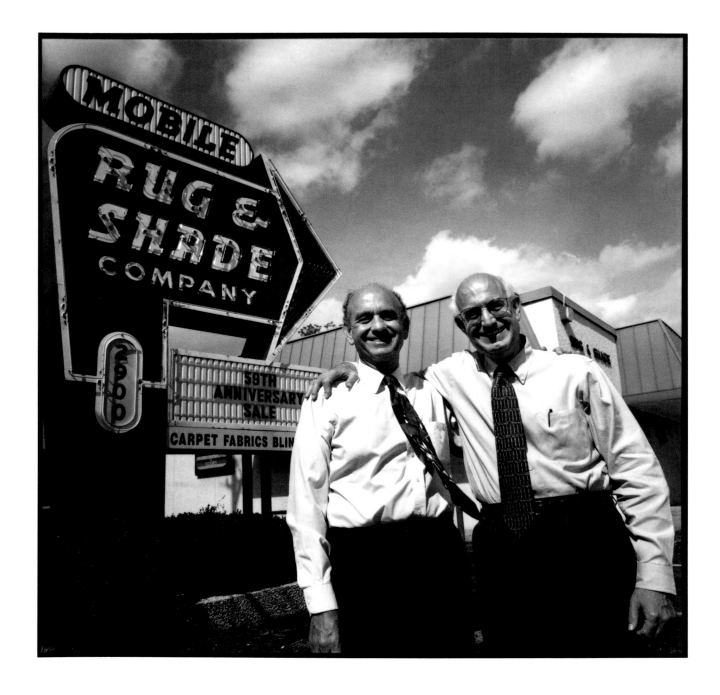

Mobile Rug and
Shade Company.
Mobile, Alabama.
Owners Jerry and
Jack Friedlander.

"There were cotton buyers and wholesale dry-goods people who would
take immigrants and give them packs on their backs to become peddlers."

MARTY NATHANSON, Natchez, Mississippi

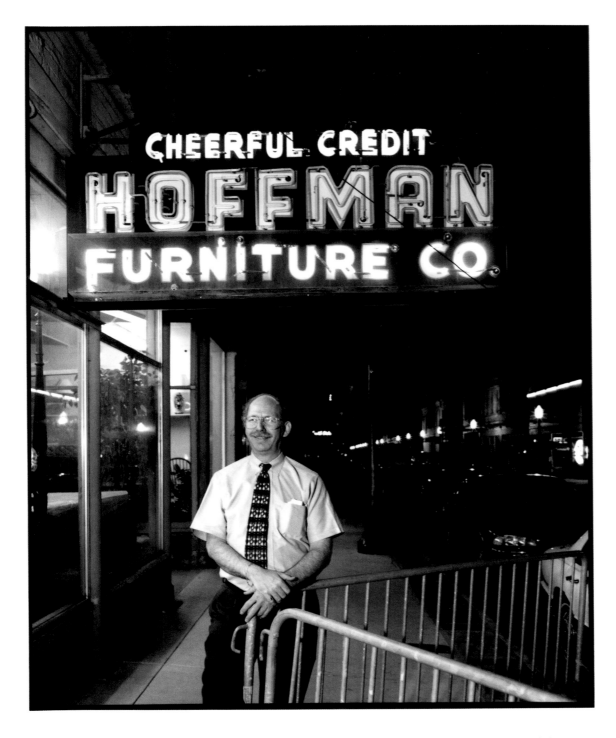

"It was very tough competition, but we were all very social and friendly. My parents played bridge every Saturday night with the owners of Blass Company for forty years. They would cut each other's throat all day Saturday and played bridge together that night."

SAM STRAUSS
Little Rock, Arkansas

Hoffman Furniture Company. Mobile, Alabama. Ron Hoffman keeps both family traditions and the family business alive in the original downtown Dauphin Street location of his family's furniture store.

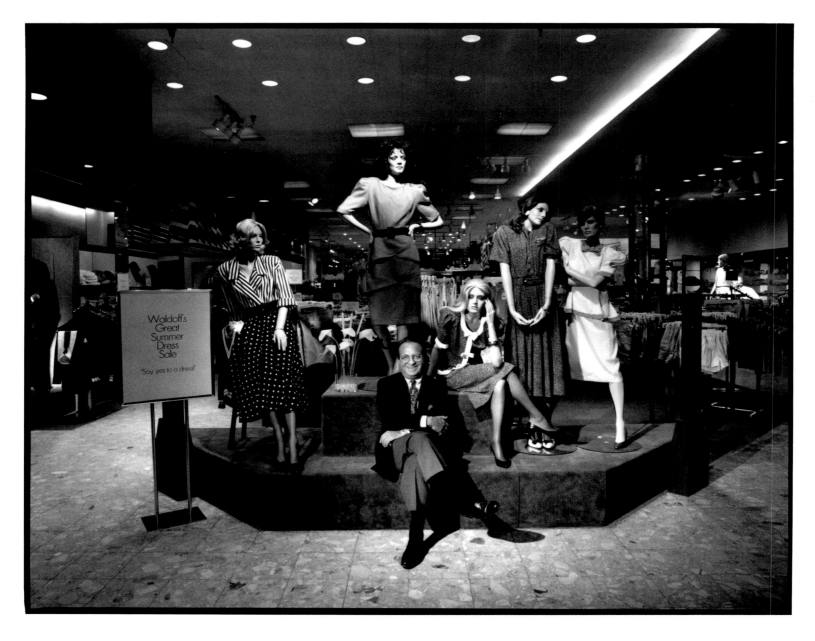

Milton Waldoff, Waldoff's. Hattiesburg, Mississippi. Founded by Milton's parents in 1924, after they came to Hattiesburg from Constantinople, Waldoff's became a major department store in Hattiesburg and was the anchor store for the first mall in the city.

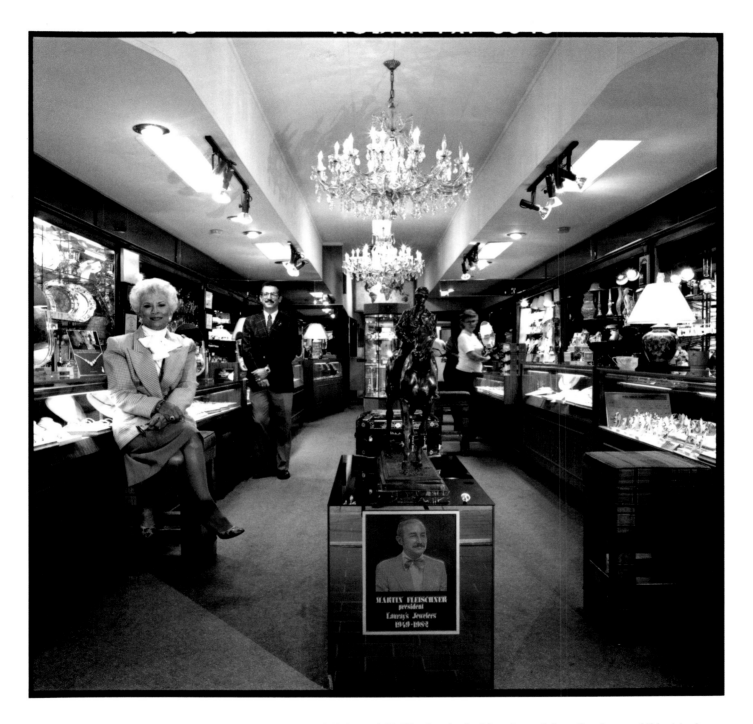

Lauray's Jewelry Store. Hot Springs, Arkansas. In 1940 Samuel H. Kirsch, who had immigrated from Russia as a child, visited Hot Springs while on vacation. He liked it and stayed. He opened Lauray's Diamond Center, now run by his daughter, Laura, and son-in-law, Mark Fleischner.

I. A. Rosenbaum. Meridian, Mississippi. A former mayor of Meridian, Rosenbaum is deeply connected to this community, where both of his parents were born. His father's father, who had come from Mobile, served in the Civil War. Rosenbaum's mother's father came to the South as a carpetbagger after the war and started a company with a relative.

Bob Cahlman, Mardi Gras
Masquerade Company.
New Orleans, Louisiana.

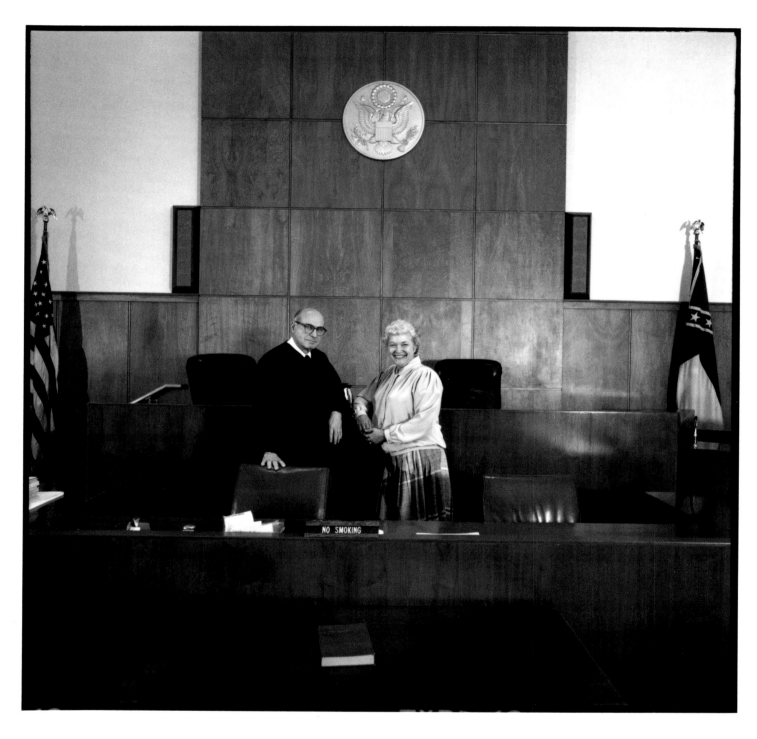

Judge and Mrs. Orlansky. Greenville, Mississippi.

"My mama worked for the Orlanskys a long time. Mrs. Orlansky would take my mama places where black people couldn't go. Mrs. Orlansky always spoke up and said, 'She came with me and she's going to stay with me. She's going to eat just like everybody else.'"

BILLIE MADDOX, Deputy Courtroom Clerk for the United States
Magistrate Judge J. David Orlansky

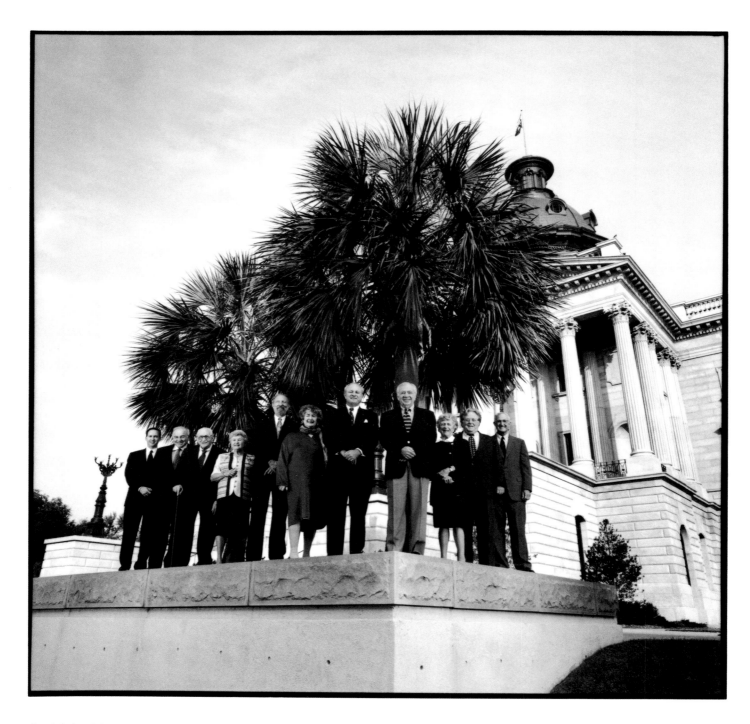

Jewish Legislators and South Carolina Mayors, Past and Present, at the South Carolina State House. Columbia, South Carolina. Left to right: Joel Lourie, Isadore E. Lourie, Hyman Rubin, Sylvia Dreyfus, David Taub, Irene Krugman Rudnick, Arnold Goodstein, Richard Moses, Harriet Keyserling, William Keyserling, and Leonard Krawcheck.

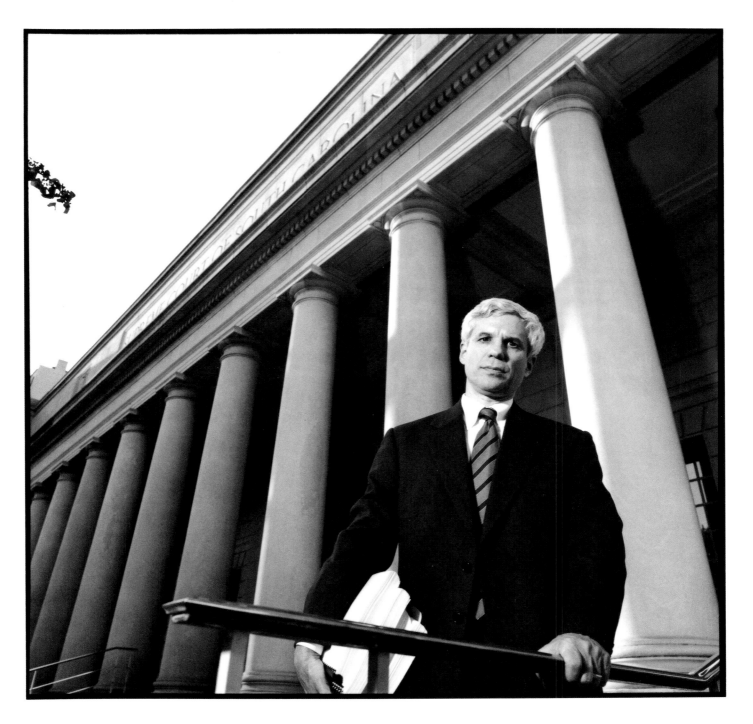

South Carolina Supreme Court. Columbia, South Carolina. David I. Bruck is a leading opponent of capital punishment and represents inmates on death row.

"Okay, I was just going to tell you how smart parents are. They don't know from beans. My daughter Sarah graduated from Tulane. She got her master's at Northwestern and she had a job teaching at Newcomb. So, after a while, she told me that she wants to go to law school. I said, 'Sarah, what do you need it for? You have a terrific job, you are making $12,000 a year. You have got three months off every summer. What are you looking for now?' And she never said anything to me. One day I see her and she is pale as a ghost. I said, 'What is going on?' She said, 'Well, I am going to night school.' She said, 'I am going to Loyola.' I said, 'That is terrible. You are not doing the kids any good and you are not doing yourself any good. If you really want it, quit your job and go to school.' So she quit the job and went to Tulane. One year she is clerking for a federal judge and the next year she is working for a law firm and they told her when she graduates they want her to come to work for them. Now she is a partner over there. So the daddy is really smart."

MICHAEL SHACKLETON, New Orleans, Louisiana

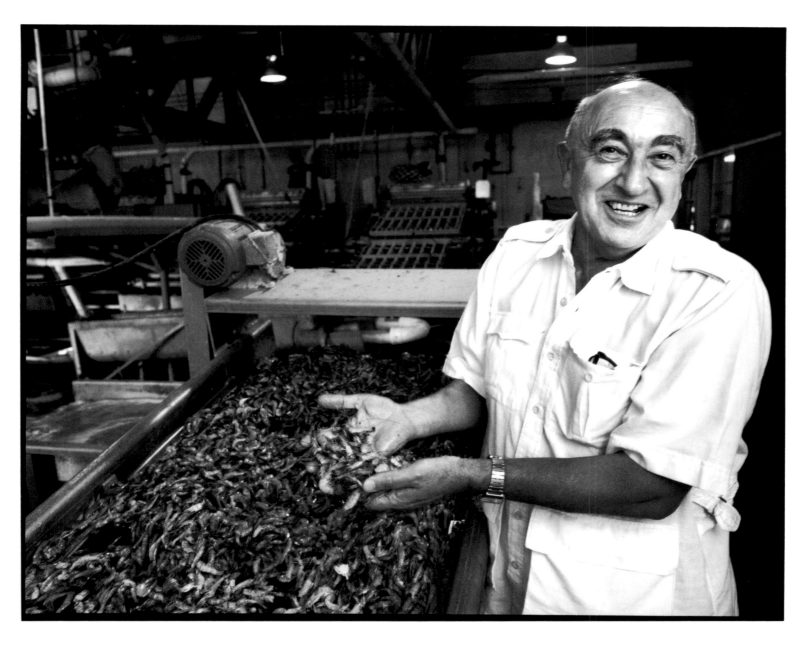

Michael Shackleton. New Orleans, Louisiana. Born in Russia, Michael Shackleton originally worked in the grocery business in New York after immigrating to this country. Dissatisfied with New York, he moved to New Orleans and became involved in the wholesale shrimp business.

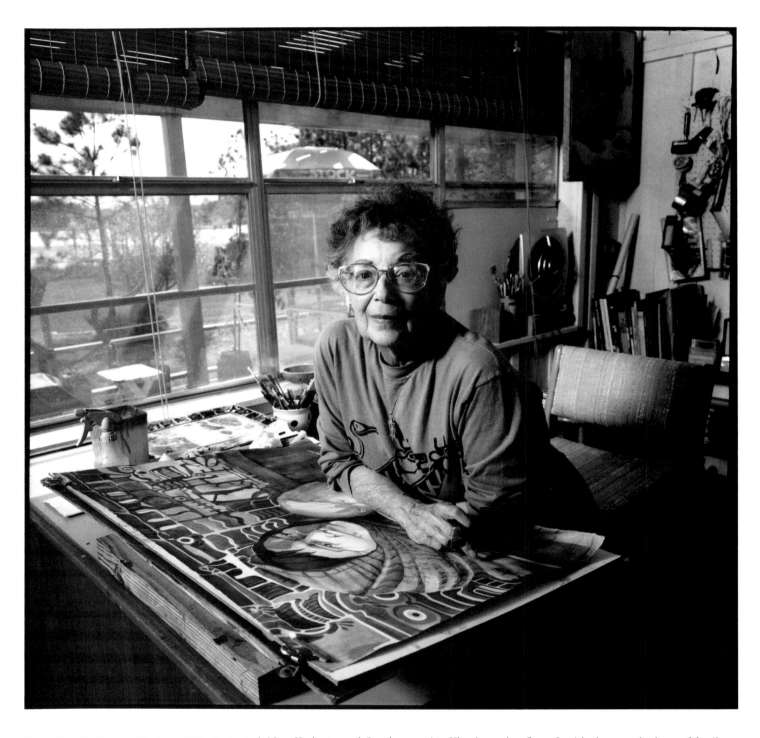

Klara Koock. Ocean Springs, Mississippi. A New York–turned-Southern artist, Klara's work reflects Jewish themes, the love of family, and the lush landscape of the Mississippi Gulf Coast.

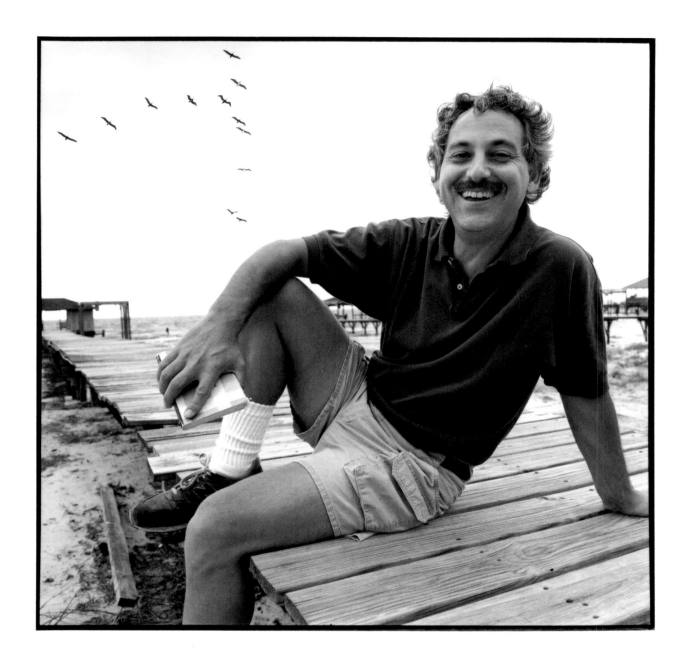

Southern Author Roy Hoffman. Mobile, Alabama. Roy Hoffman relaxes on the pier over Mobile Bay, in front of the house where he's lived in recent years at Point Clear, Alabama. His first novel, *Almost Family*, and many of his other writings draw upon his Southern Jewish roots and sensibilities. Hoffman, a native of Mobile, comes from a long tradition of story-telling.

"All the Jews in the Delta know one another."

BETTY GOLDSTEIN, Greenville, Mississippi

"Every now and then in the boxes of shoes that my grandfather and my uncle would send to us in Shreveport to fix and sell, they would include things like rye bread."

PAUL GREENBERG, Pine Bluff, Arkansas

Paul Greenberg, Pine Bluff, Arkansas. Greenberg's Polish father settled in Shreveport, Louisiana, where he began a business repairing and selling secondhand shoes. Mr. Greenberg pursued a "professional career" and went to Arkansas as a writer for the *Pine Bluff Commercial*. In 1969 he was awarded the Pulitzer Prize for his editorial writing and in 1992 he became editorial-page editor of the *Arkansas Democrat-Gazette*.

"Dad would tell this story about once a week. He had a really good friend who was a farmer. One Saturday night, with quite a few people in the store, his friend spread-eagled himself against the screen door and yelled, 'I'm so glad I'm not a Jew,' and Dad looked up and said, 'Well, so are we. We Jews would be ashamed of you.' And everybody in the store just fell out laughing."

GERRY BARKOVITZ
Hayti, Missouri

Connie Kaplan, Publisher and Editor, *Kaplan Herald.* **Kaplan, Louisiana.** Connie Kaplan is the last in a long line of Kaplans who contributed to the founding and building of this town deep in the bayou country of south Louisiana.

My grandfather Jake Aronov came to this country around 1912 through the port of Galveston from Kiev. He traveled to Columbus, Georgia, where he obtained employment in a warehouse stacking and moving crates. On one particular day my grandfather had to bring some crates down from an upper level. When he hesitated, because of the height, his supervisor called to him, 'Aronov, why don't you jump down. If you break your neck, that would be one less Jew in the world.'

"Well, my grandfather slowly climbed down from where he was, left the warehouse, and went to visit a Jewish scrap-yard operator he knew. The man loaned him a horse, a wagon, and some money to get started. He began traveling around the countryside buying scrap and bringing it back to Columbus to sell. On one trip, when his wagon was fully loaded, which meant that all his savings were invested in the goods in the wagon, his horse was struck and killed by lightning. This forced him to abandon the wagon and scrap to go in search of a new horse. When he returned to his wagon, all the scrap he had collected was gone.

"My grandfather went back to the merchant who had helped him get started. The merchant refused to make him another loan, saying that my grandfather was too good at what he did, and if he helped him again, he would become a competitor. So my grandfather found another sponsor, this time a non-Jewish merchant.

"He eventually did well enough to afford his own scrap-metal yard. In 1919 when the Tuskegee Institute in Alabama burned down, my grandfather was awarded the contract to buy the salvage from the buildings. Because Montgomery was closer to Tuskegee than Columbus, Georgia, he moved his family here. And that's how the Aronovs got to Montgomery from the Ukraine."

JAKE ARONOV, Montgomery, Alabama

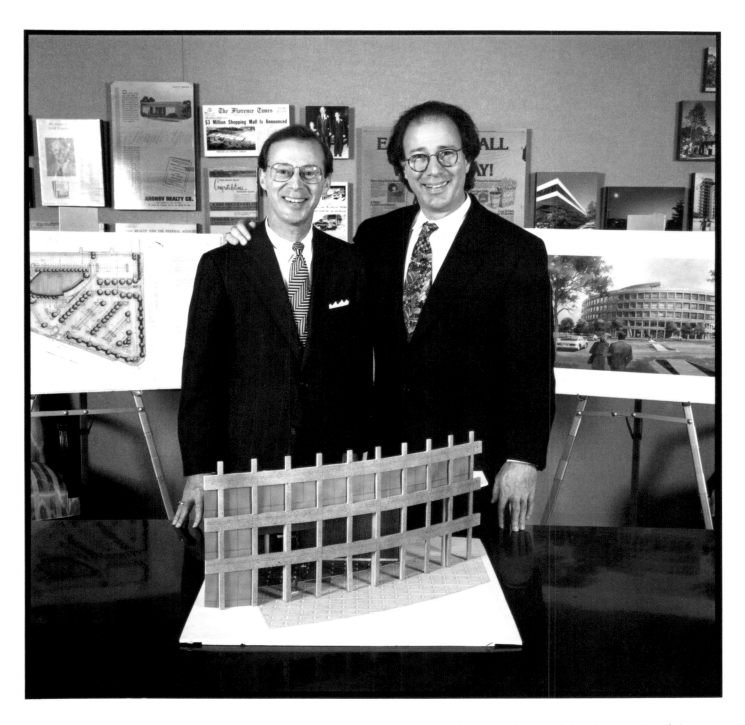

Aronov Family. Montgomery, Alabama. Owen and Jake Aronov lead Aronov Realty, begun by their father, Aron, and his father, Jake. Jake started as a scrap-metal merchant, then went into the auto-parts business, and eventually, real estate. Today, Aronov Realty is one of the top thirty real estate developers in the United States and the largest privately owned real estate company in the Southeast.

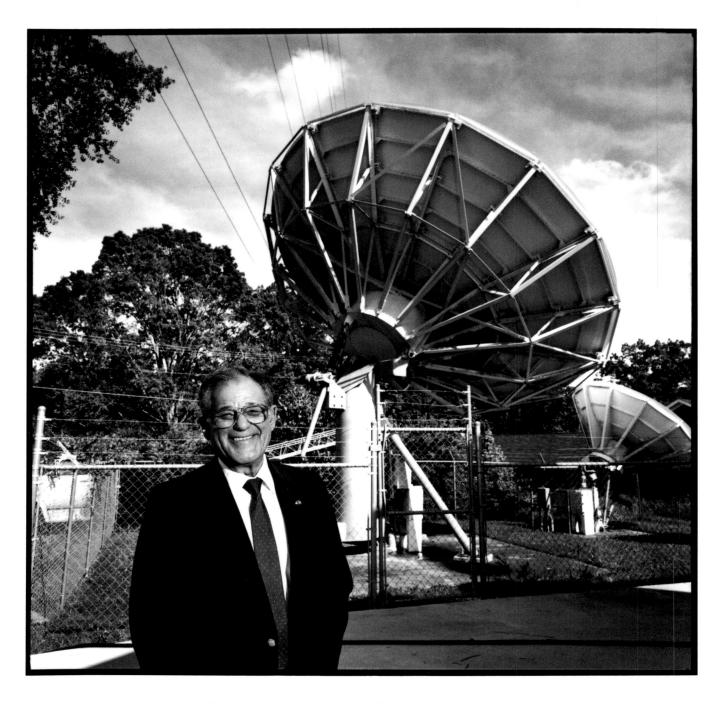

Jack Cristil. Tupelo, Mississippi. Best known as the "voice of the Mississippi State Bulldogs," Jack Cristil is a prize-winning sportscaster and news personality. From the time he was six years old, Cristil knew what he wanted to do. "I was going to broadcast ballgames. I mean, it was just that simple. I never thought of anything else. I wasn't going to be a brain surgeon or ditchdigger—I was going to be a broadcaster. And radio was big in those days. It was before the advent of television."

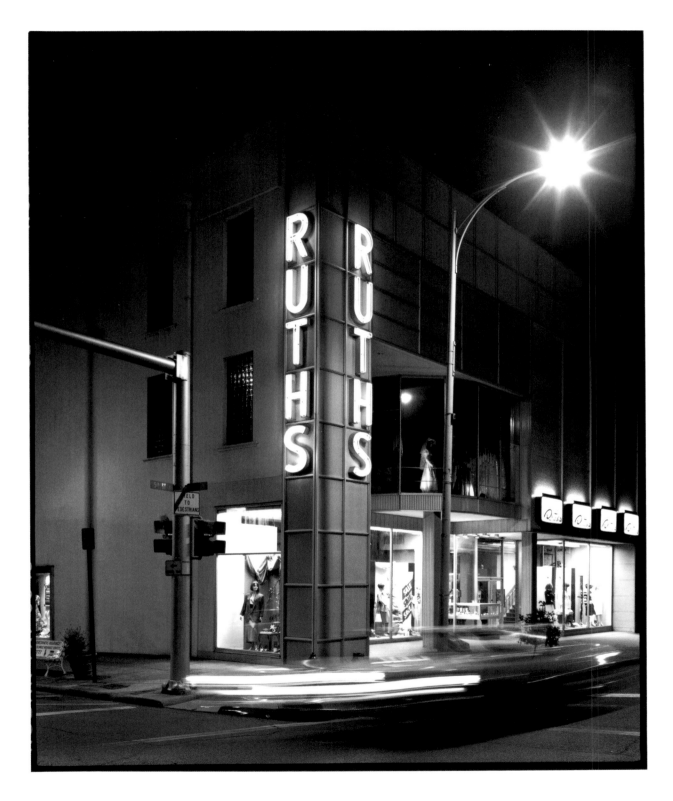

Ruth's Department Store. Columbus, Mississippi. Ruth's Department Store, a mainstay of downtown Columbus, prides itself on its full-service reputation. It was named by owner Archie Bernstein for his wife, Ruth.

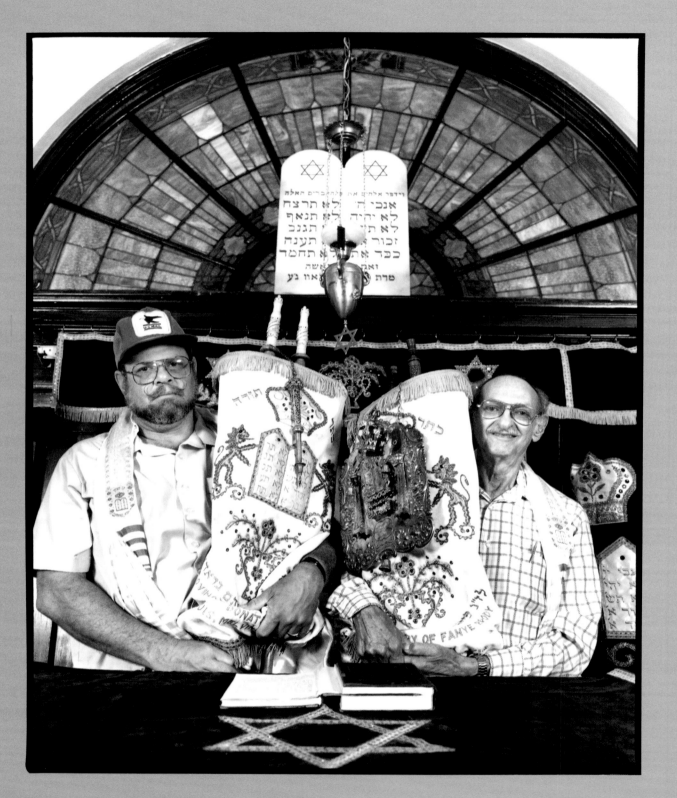

Joe Martin Erber and His Uncle, Meyer Gelman. Greenwood, Mississippi. Congregation Ahavath Rayim is the last Orthodox synagogue in Mississippi.

"When you live in a big city, like Miami, Chicago, or New York, there are thousands upon thousands of Jewish people. You can let somebody else represent Judaism because of the large numbers. This is not true in a small community. You are the Jewish community, whether you like it or not. You accept this responsibility. You do those things that are expected of you. You go a step beyond and you constantly keep in the back of your mind that you have got to be a little different and a little special. You go out of your way to make sure that you do not cast aspersions upon the Jewish people by your individual actions."

JACK CRISTIL, Tupelo, Mississippi

Magnolias and Menorahs

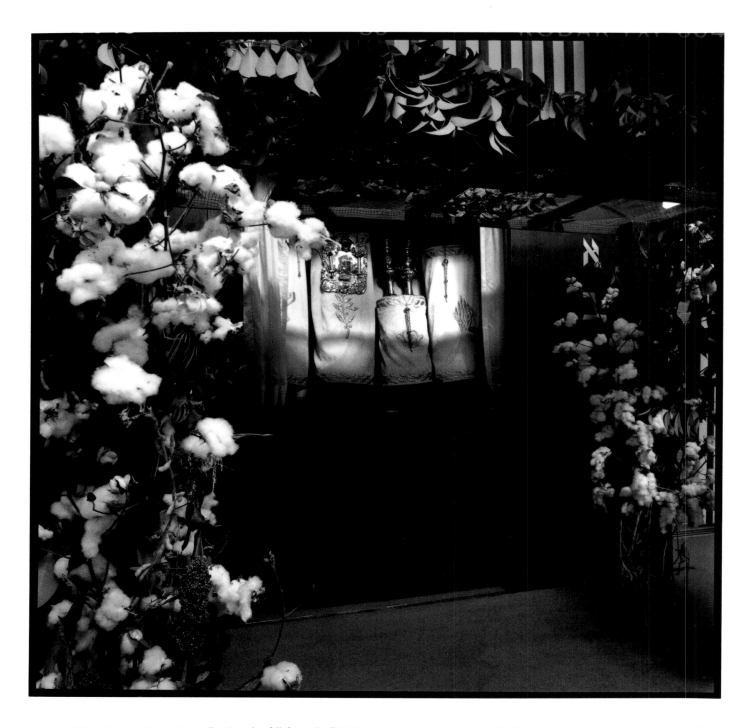

Sukkot. Vicksburg, Mississippi. During the fall festival of Sukkot, a temporary structure is built to commemorate the wandering of the freed Hebrew slaves from Egypt. In the Mississippi Delta, these booths are often decorated with newly harvested cotton, soybeans, and corn stalks.

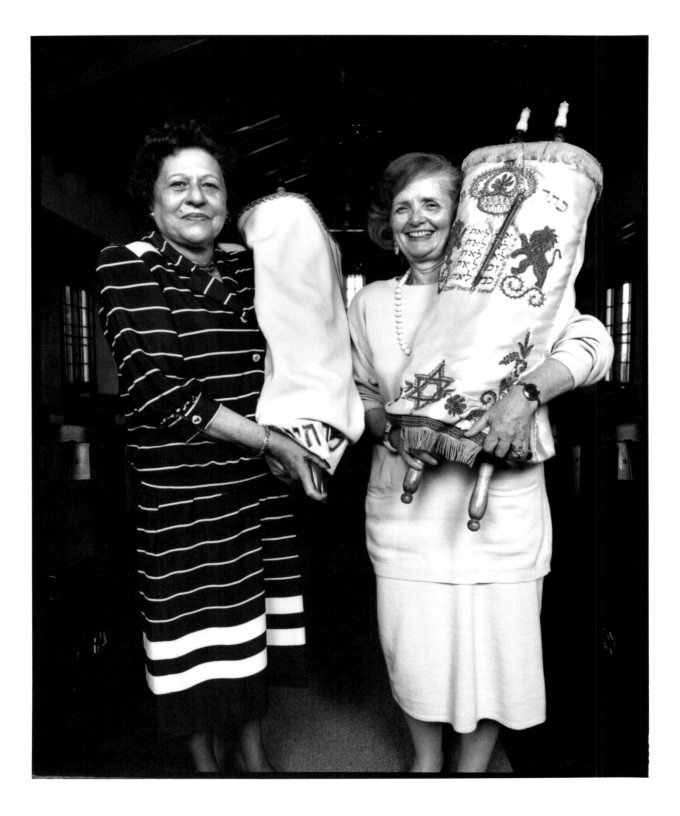

Betty Kohn and Barbara Edisen, Congregation Shaarey Zedek. Morgan City, Louisiana. On a return visit to Morgan City, Barbara Edisen and her cousin visit the synagogue that Barbara attended throughout her childhood.

"I used to conduct services when we didn't have a rabbi. I instructed children for bar mitzvah; some were girls and some were boys. I'd give up my Wednesday afternoon golf so I could teach."

RAYMOND COHEN
Montgomery, Alabama

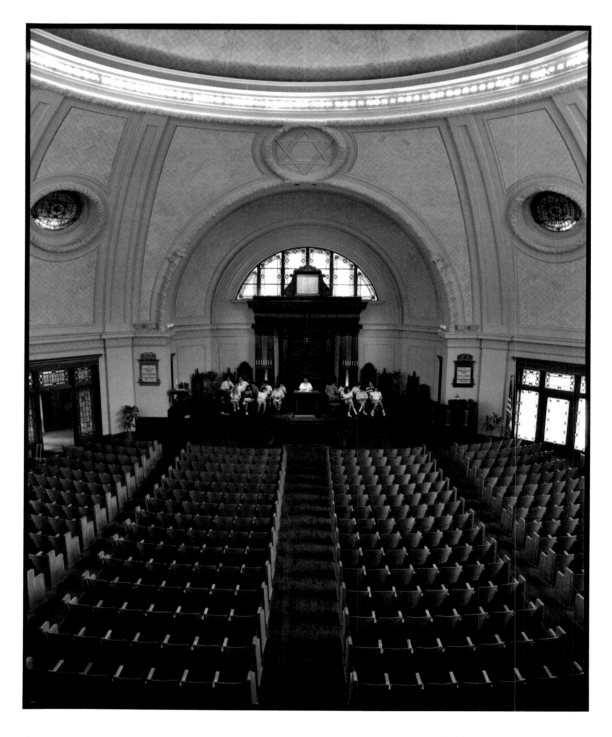

Confirmation Rehearsal at Touro Synagogue. New Orleans, Louisiana. High school students practice for their upcoming Confirmation service, a tenth-grade rite of passage among Reform congregations.

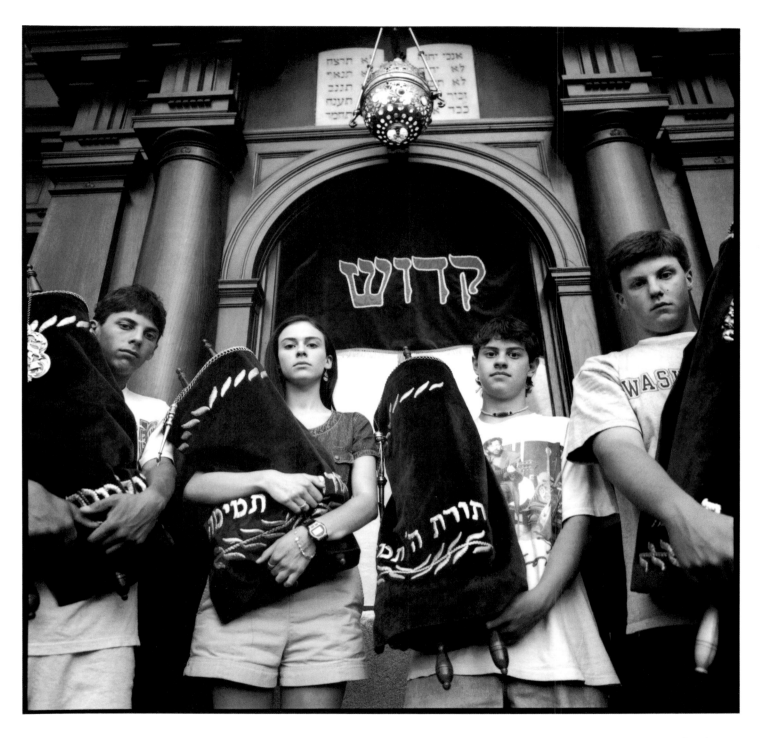

Temple Emanu-El. Birmingham, Alabama. Tenth-grade students at Temple Emanu-El, which was founded in 1882, rehearse for their Confirmation ceremony in the synagogue's historic sanctuary.

"I work with the bar and bat mitzvah kids to make sure that they know what it means to be Jewish and that they have a strong identity. Here (in Tupelo), the first thing you're asked is 'What church do you go to?'"

MARK PERLER, Tupelo, Mississippi

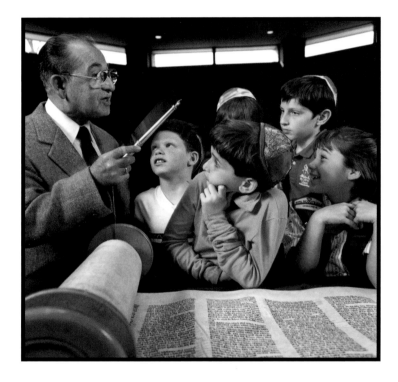

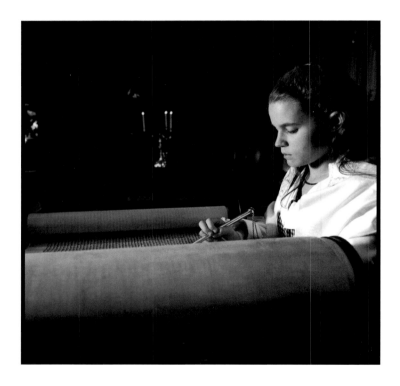

Torah Study, Ati' Day Yisroel School. Little Rock, Arkansas. Students study the Torah as part of their bar and bat mitzvah training with Rabbi Seymour Weller at Augdath Achim Synagogue. Organized in 1903, Agudath Achim is the only Orthodox congregation in the state. Rabbi Weller sees a growing movement among his congregants toward more tradition and "Yiddishkeit"— a sense of strong Jewish identity.

Bat Mitzvah. Mobile, Alabama. Cheryl Spain reads from the Torah during her bat mitzvah at the historic Springhill Avenue temple.

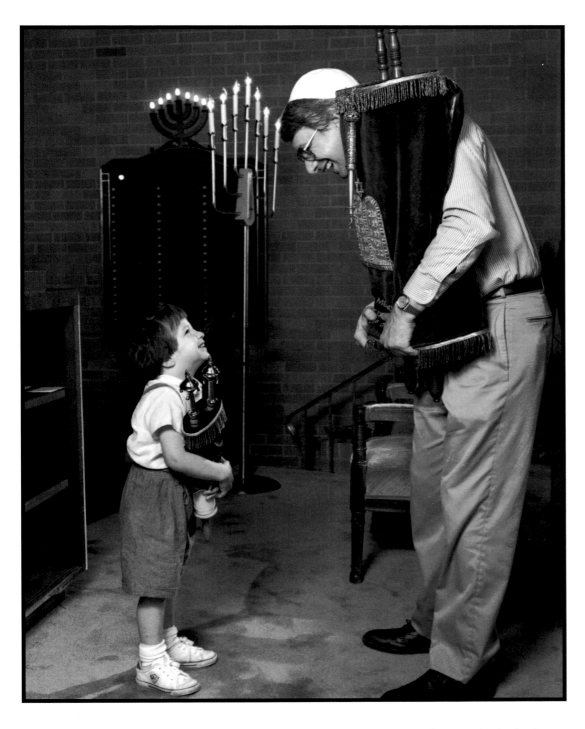

"This is where our personal Judaism has flourished. You can't stand on the sidelines here and watch it happen, or it won't happen."

LOU DORFMAN
Long Beach, Mississippi

Mark Perler and Eliot Copen, Temple B'nai Israel. Tupelo, Mississippi. Perler, an active lay leader for the Jewish community, passes on rituals of Torah to a young member of the Temple religious school. The congregation, established in 1939, is small but growing, due to new industry in the region.

"I was the treasurer. Believe it or not, our dues were twenty-five cents a month. Nobody paid by the year—that's three dollars a year. Every month I used to get in my car and go around and collect the dues for Ladies Auxiliary. Those were the days."

FREEDA RITMAN, Agudath Achim Sisterhood (formerly Ladies Auxiliary), Shreveport, Louisiana

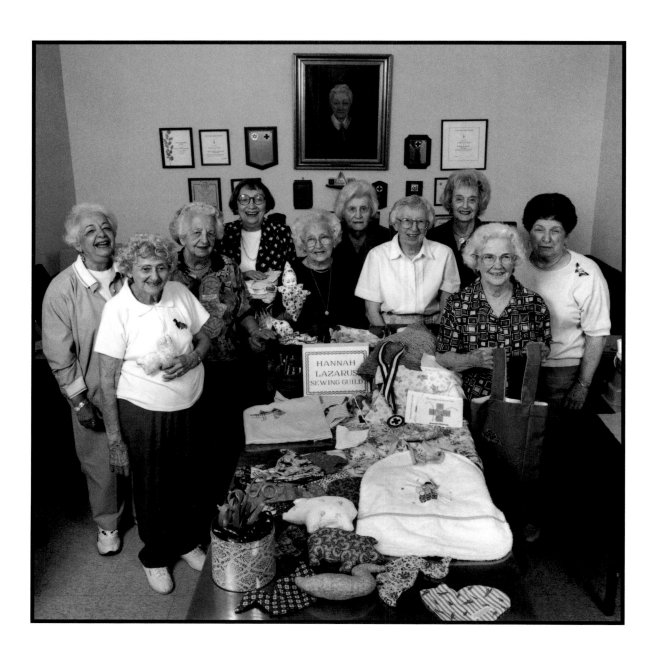

Hannah Lazarus Sewing Guild. Birmingham, Alabama. The guild has its own room on the lower floor of Temple Emanu-El where they have been meeting for years to perform their *tzedakah,* acts of loving-kindness.

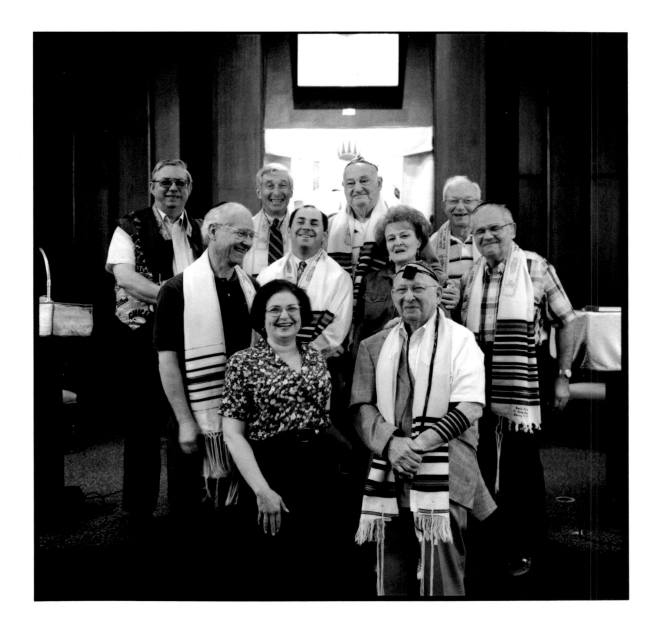

Daily Minyan.
Birmingham, Alabama.
The daily minyan at
Temple Beth El is led by
members of the synagogue
who have been praying
together for years.

"Blytheville Temple is about to close because we simply cannot get the membership anymore.
The Jewish population has decreased so much. We depended on Kennett and Caruthersville and
Blytheville and all the neighboring communities. Our Jewish population tragically is dying out.
I would say in another generation unless some professional people move in it will be gone."

SOL ASTRAKAN, Kennett, Missouri

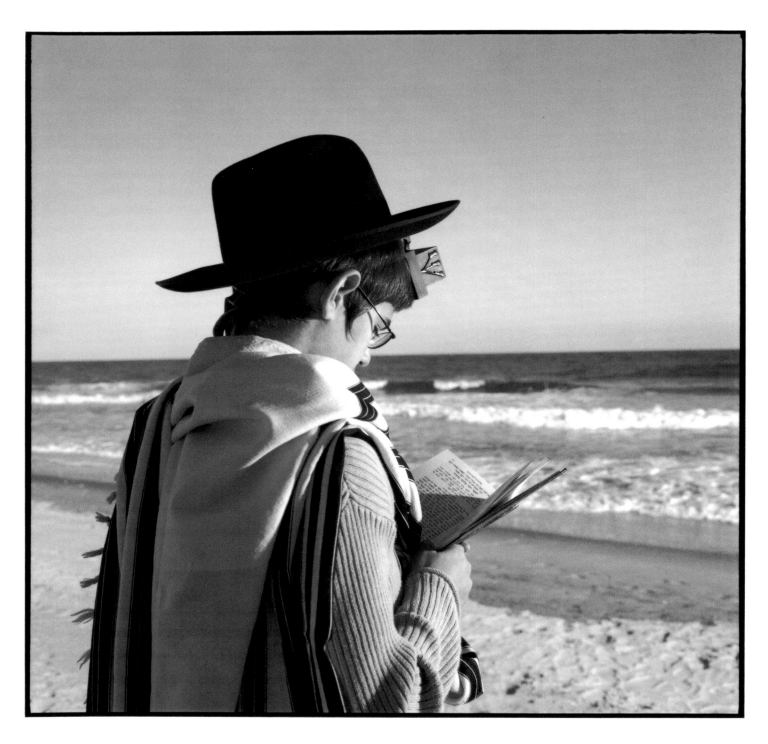

Avram Aizenman. Myrtle Beach, South Carolina. Son of the rabbi and director of the Lubovitcher Chabad, an Orthodox day school, he recites morning prayers on the shores of the Atlantic Ocean.

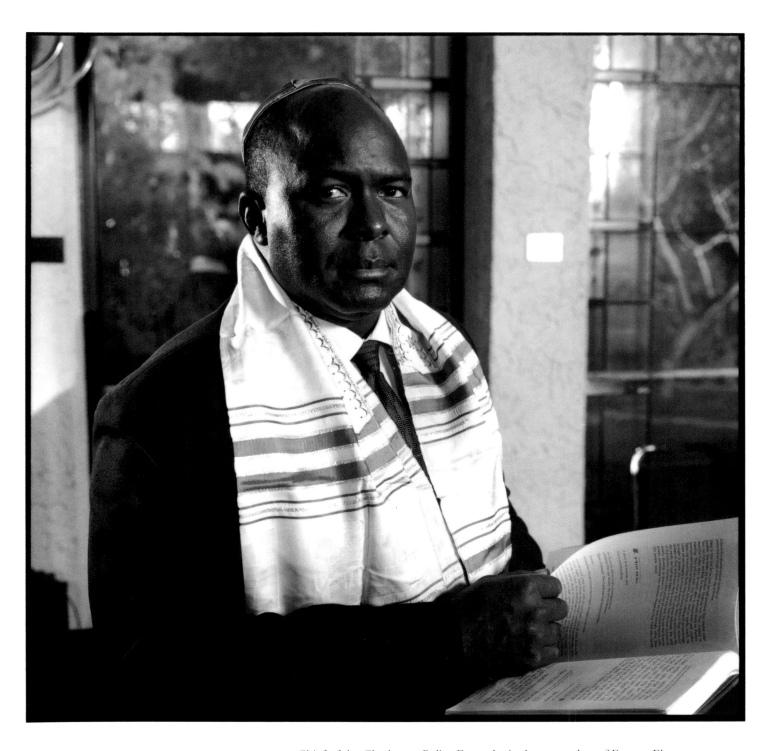

Reuben Greenberg. Charleston, South Carolina. Chief of the Charleston Police Force, he is also a member of Emanu-El, the Conservative synagogue in Charleston.

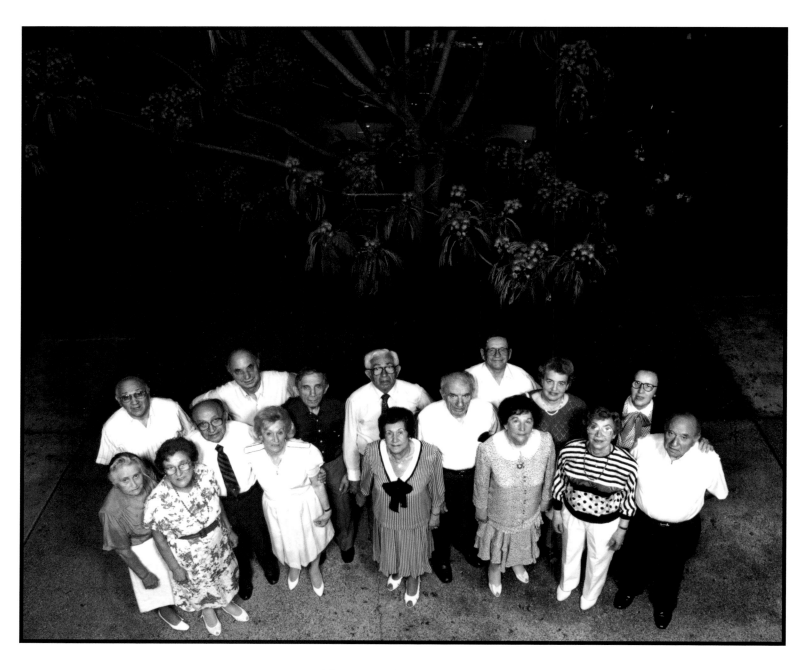

New Americans Social Club. New Orleans, Louisiana. This group of Holocaust survivors meets regularly to socialize and to share experiences of survival and loss.

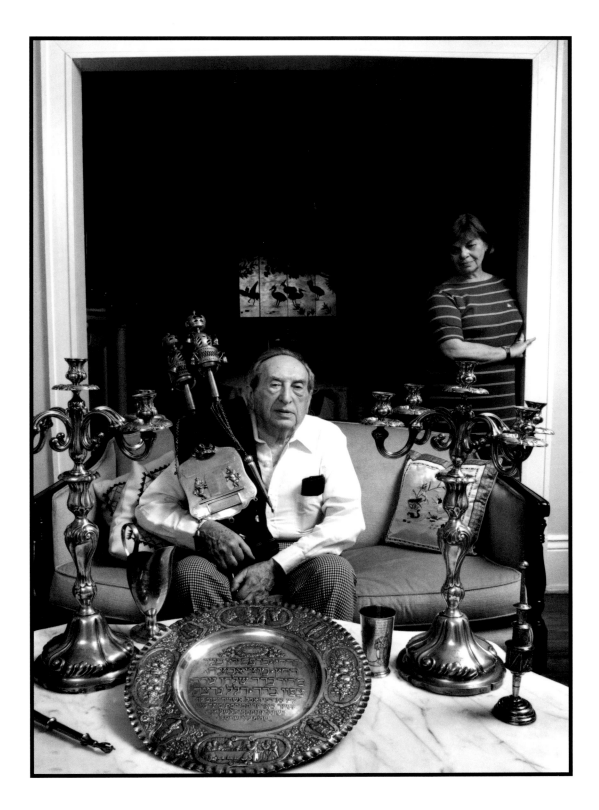

Harry Nowalsky. New Orleans, Louisiana. Among the first U.S. Army personnel allowed back into liberated European cities, Harry Nowalsky was able to help rescue Judaica that had been confiscated from imprisoned or deported Jewish citizens during the war. During the course of his service in the borough of Kreuzberg in Berlin, he arranged to have the synagogue reopened, helped secure matzo for Passover, and was able to reinstitute kosher slaughtering of animals. To show their gratitude, the community gave him a silver seder plate, silver candelabra, and kiddish wine decanter, all objects that had been buried in a cemetery during the war.

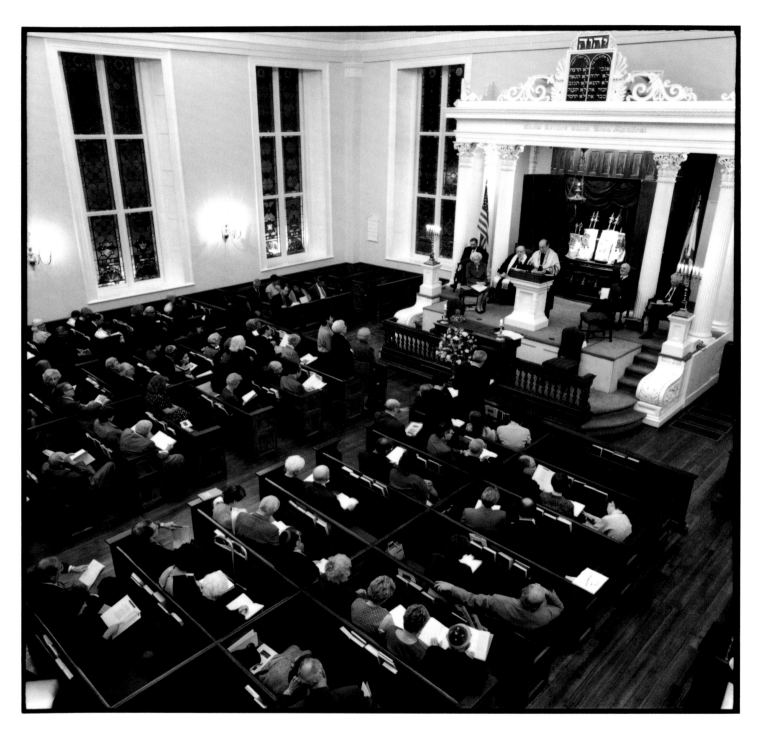

Kahal Kadosh Beth Elohim, 250th Anniversary Service. Charleston, South Carolina. Organized in 1749, Beth Elohim is the fourth-oldest congregation in the country and became the first Reform congregation in America in 1840.

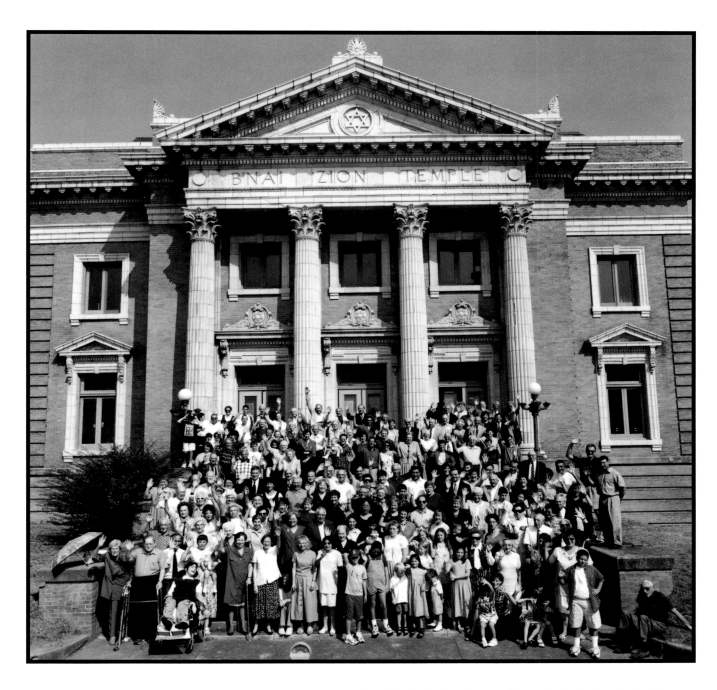

Original Building of Temple B'nai Zion. Shreveport, Louisiana. Jacob Bodenheimer is generally credited as being the first Jew to have settled in northwestern Louisiana, in 1827. Originally a peddler who traveled by keelboat and traded with the Caddo Indians, Bodenheimer eventually cleared land for a farm, built a boat, and operated a ferry service on Lake Bistineau. While the zenith of the Shreveport Jewish community was in the 1950s, there are currently approximately 850 Jews in the area with two synagogues, B'nai Zion (Reform), and Agudath Achim (Conservative).

"You have a mixture. You have some whose backgrounds are Orthodox. Some are Conservative, some are Reform. It's a mutual understanding that the Shabbat services are Reform and the High Holy Days are Conservative. It is the best we can do under the circumstances. Each individual grasps as much as he or she determines they want."

JACK CRISTIL, Speaking about the synagogue in Oxford, Mississipi

Dr. Ralph Friedman, Louis Friedman, and Vinnie Prochilo, members of Congregation Beth Shalom. Oxford, Mississippi. In 1978, soon after Ralph Friedman and Vinnie Prochilo retired to Oxford, Ralph's childhood home, they began to organize the small Jewish community. Ralph Friedman describes its beginnings. "We met this Jewish couple that was going to law school. We decided, let's just start a little congregation. At that first meeting, we had forty-four people, some friends came from Coffeeville, and some came from Okolona, and we had quite a crowd there. The next time we had the meeting here. Then we decided we would just have all meetings here. We put in rows of chairs. That's how it all started."

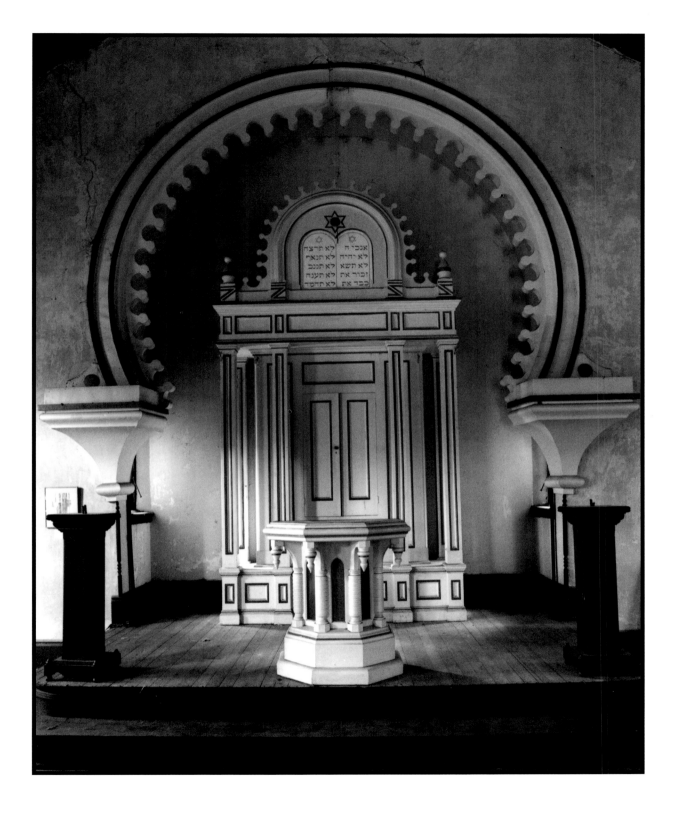

Interior, Temple Gemiluth Chessed. Port Gibson, Mississippi. Located on Church Street along with the many churches in Port Gibson, Temple Gemiluth Chessed no longer has any members. Legend has it that when General Grant marched his troops through Port Gibson, he spared the town because he thought it was so beautiful.

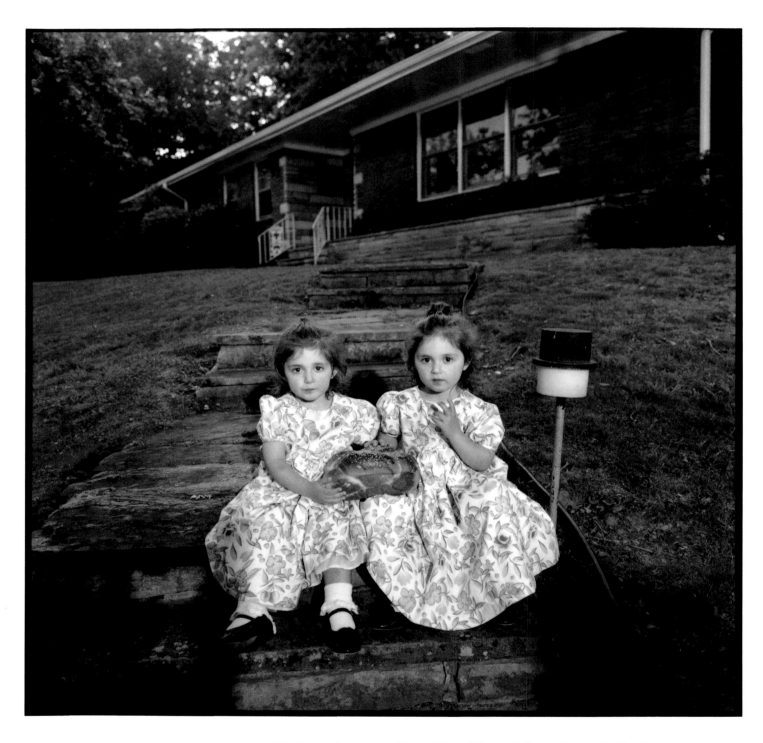

Challah for Shabbat. Birmingham, Alabama. Shabbat is the most anticipated day of the week for the Posner family. The two youngest of the family's six children await the beginning of Shabbat with a homemade loaf of challah between them.

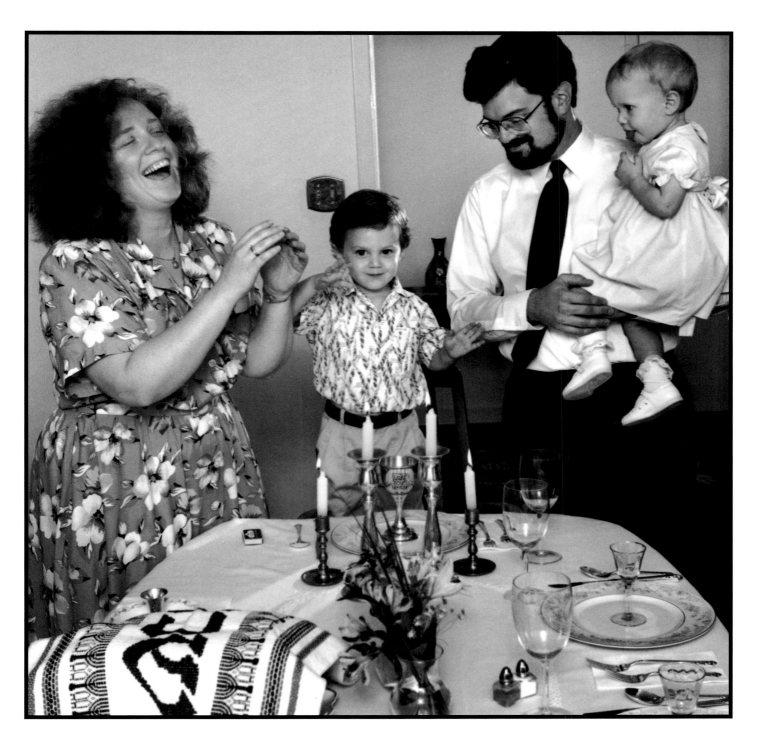

Shabbat. Jackson, Mississippi. Rabbi Eric Gurvis, his wife, Laura, and children, Benjamin and Sarah, celebrate Shabbat.

"When I started school at Peter Rabbit Kindergarten I learned Shema Yisrael was for home and synagogue, and Our Father Who Art in Heaven was for kindergarten."

JOE MARTIN ERBER, Greenwood, Mississippi

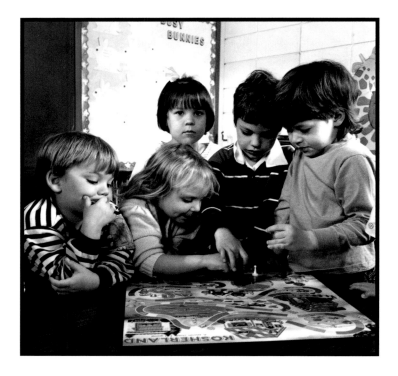

Creating Contemporary Judaica, Springhill Avenue Temple. Mobile, Alabama.

Nursery School, Temple B'nai Israel. Little Rock, Arkansas.

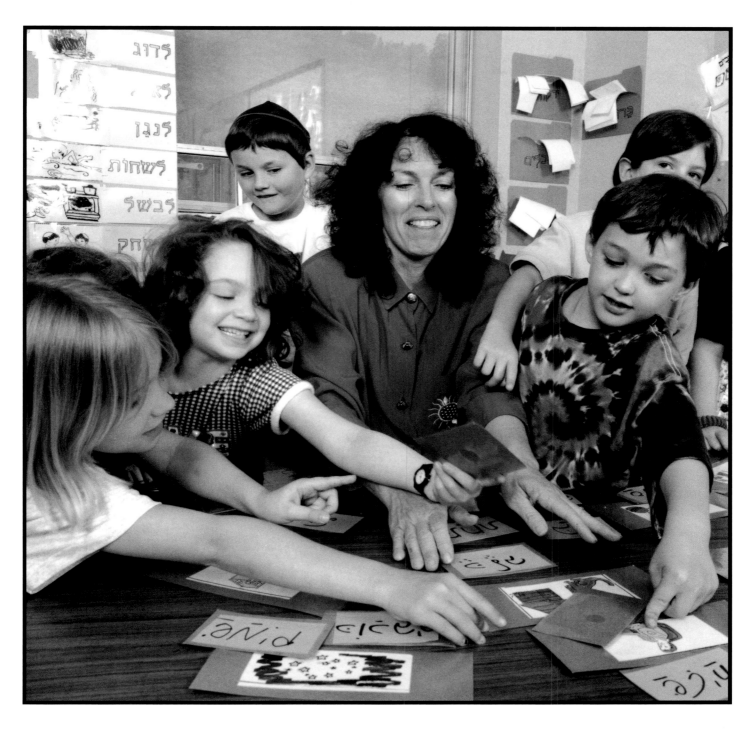

Jewish Learning. Birmingham, Alabama. Students at N. E. Miles Day School learn and play at their Jewish day school, where they have a Jewish and a secular curriculum.

"That's why SOFTY (Southern Federation of Temple Youth) and camp are so important to our children. The first time one of my little granddaughters went she said, 'There's nothing there but Jews.' She was used to being the only Jew wherever she went!"

VIVIAN LEVINGSTON, Cleveland, Mississippi

Temple Youth Group. Mobile, Alabama. Members of the Reform temple youth group relax during the break in the Sunday-afternoon meeting at the home of their advisor.

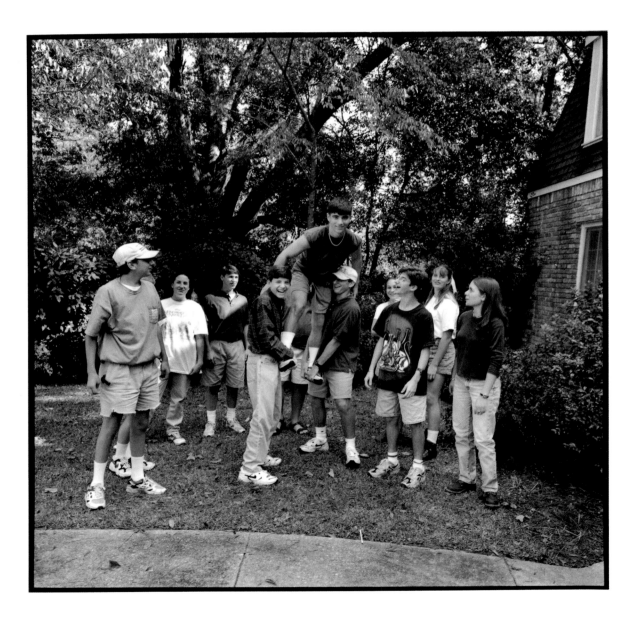

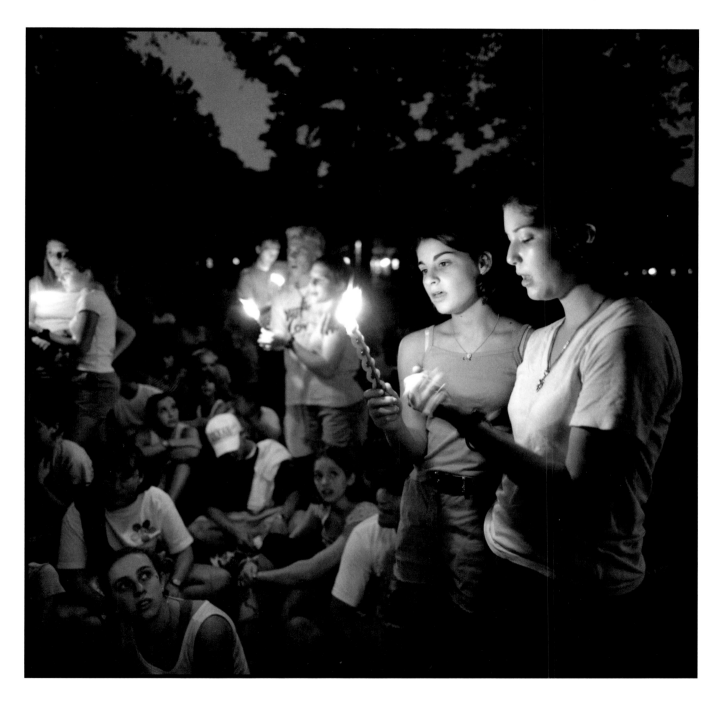

Havdallah Service, North American Federation of Temple Youth (NFTY) Southern Institute, Henry S. Jacobs Camp. Utica, Mississippi. Saturday evening after three stars appear in the sky, havdallah signals the end of Shabbat and the beginning of the rest of the week. Weekends like this one at Jacobs play an important role in creating and sustaining an extensive Southern Jewish network that will last a lifetime.

"The first time I realized I was really different was during high school when I was not invited to join a sorority because I was Jewish. My best friend was invited and she joined and we weren't really good friends after that. Years later at our thirtieth high-school reunion she came up to me and said, 'Do you remember when I was asked to join the sorority and you weren't? I always felt badly about that because that meant that you weren't saved.'"

CELESTE ORKIN, Jackson, Mississippi

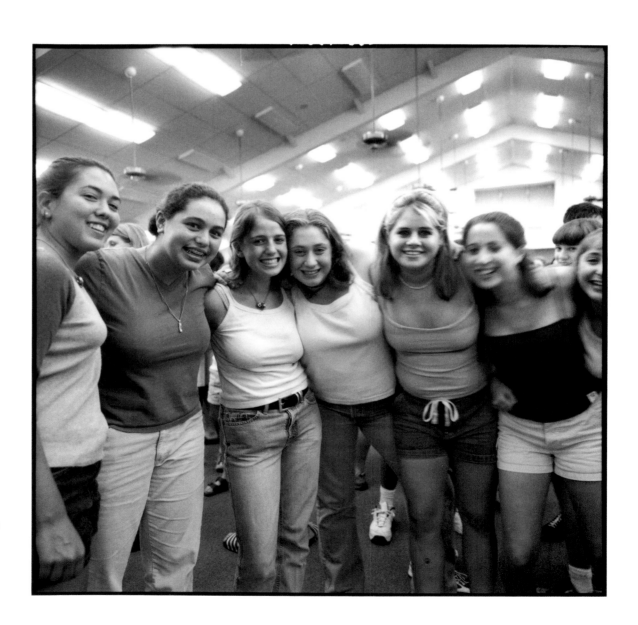

Group Hug, NFTY Southern
Institute, Henry S. Jacobs
Camp. Utica, Mississippi.

88

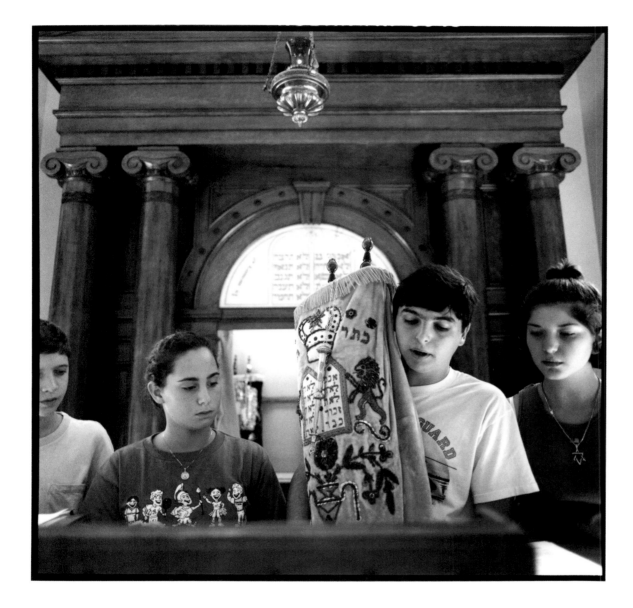

Torah Service at Henry S. Jacobs Camp. Utica, Mississippi. Gathered together for a regional youth-group event, high school students pray together.

"The major difficulty in growing up and raising children in a small town is maintaining a Jewish identity and imparting that to your children. With my own four children, the camp [Henry S. Jacobs] played a key role."

GERALD POSNER, M.D., Opelousas, Louisiana

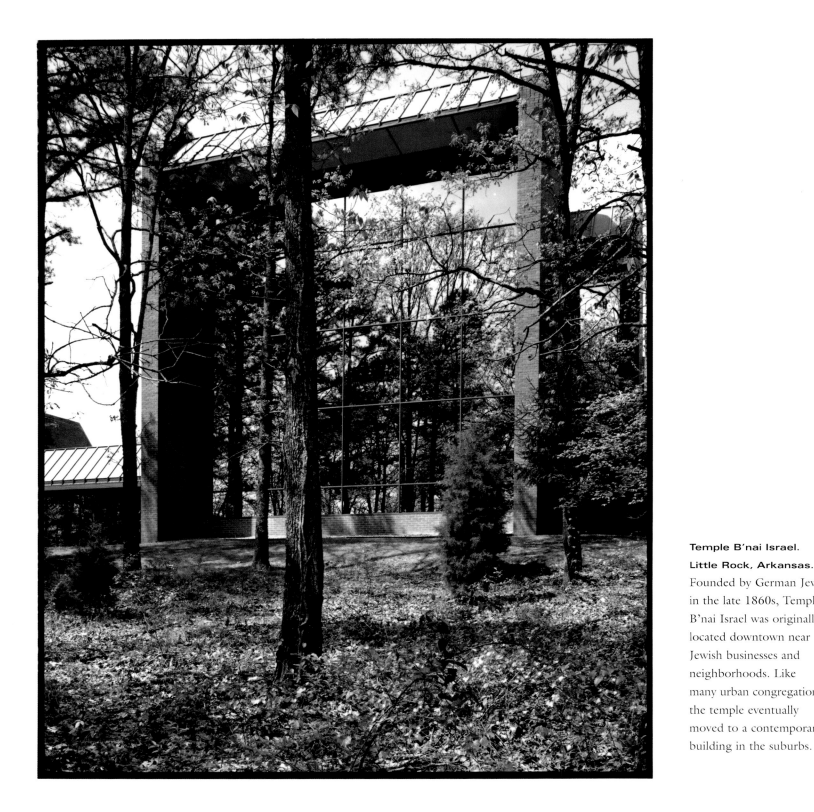

Temple B'nai Israel.
Little Rock, Arkansas.
Founded by German Jews in the late 1860s, Temple B'nai Israel was originally located downtown near Jewish businesses and neighborhoods. Like many urban congregations, the temple eventually moved to a contemporary building in the suburbs.

Temple Beth El.
Lexington, Mississippi.
This shrinking Jewish
community has services
once a month when
the rabbi from Jackson
comes to conduct them.
The children in the
community travel the
sixty miles to Jackson
for Sunday School.

Touro Synagogue. New Orleans, Louisiana. Touro Synagogue is the oldest Jewish house of worship in America beyond the original thirteen colonies. Founded in 1828, the present-day Touro is an amalgam of two earlier New Orleans congregations, one founded by German Jewish settlers, the other by Spanish-Portuguese families of largely Sephardic background who arrived from South America and the Caribbean. The name "Touro" was adopted in 1881, when the two congregations merged and honored the memory of the New Orleans philanthropist and community leader Judah Touro. Its famous "Jazz Fest Shabbat," which features music by the New Orleans Klezmer All-Stars, coincides with the New Orleans Jazz and Heritage Festival.

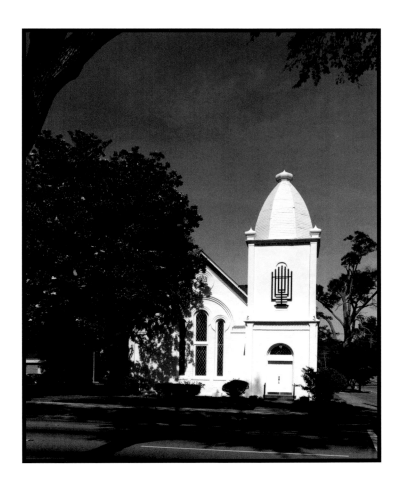

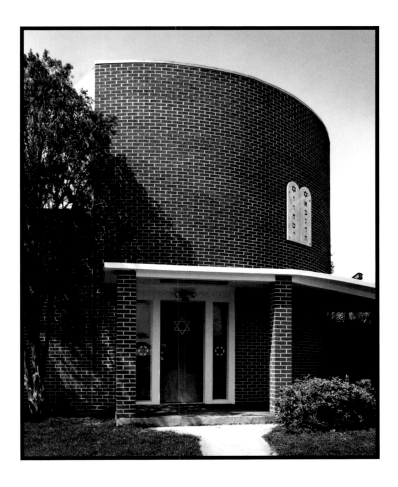

Temple Beth El. Anniston, Alabama. Anniston's Jewish history goes back to 1884, when Leon Ullman opened Ullman Brothers Department Store. Other Jews soon followed, and in 1893 they began building Temple Beth-El. The building, which is the oldest synagogue still in use in Alabama, was actually built by the Ladies Hebrew Benevolent Society. They began fund-raising in 1890, bought a lot for $1,500 and built the building for $2,400, then turned the land and building over to the congregation in 1907, debt free, for $1. Today, according to Beth-El president Fred Kemp, there is an enthusiastic but small group in Anniston. "We're going to have our problems, because we've got a lot of octogenarians. Some young people have recently moved into the community, but not enough."

Temple Beth Israel. Biloxi, Mississippi. As the only congregation on the Mississippi Gulf Coast, Temple Beth Israel provides a unique mix of Orthodox, Conservative, and Reform traditions.

"Once the children went to college, they never really came back, except to visit their family. There was nothing for them here."

BESS SELIGMAN, Boca Raton, Florida, formerly of Greenville, Mississippi

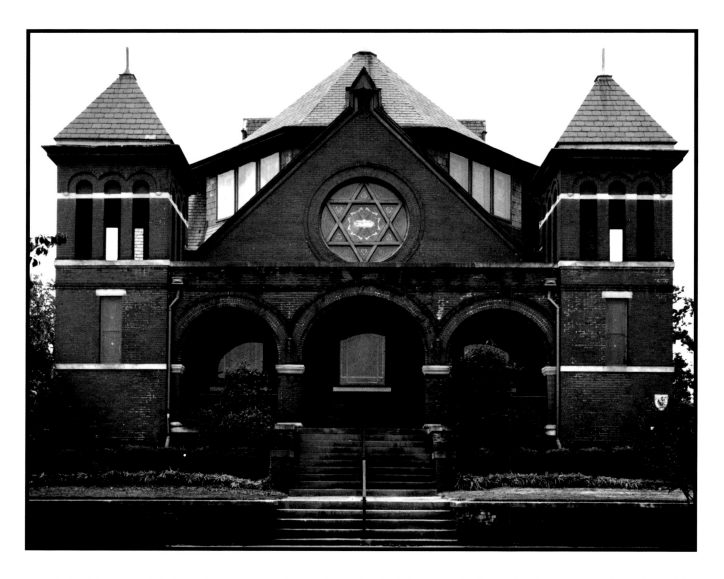

Temple Mishkan Israel. Selma, Alabama. The first Jewish settlers in Selma arrived prior to the Civil War, but the city's Jewish community did not officially begin until 1867 when residents began holding services in their homes. Selma's Jewish community has always been well represented in the civic life of the city; several Jews have served as mayors and as presidents of the Chamber of Commerce. The members, who now number fewer than twenty, remain faithful to the synagogue and its historic presence in Selma. But still, when leaving the building after services, members joke, "Last person left, turn out the lights."

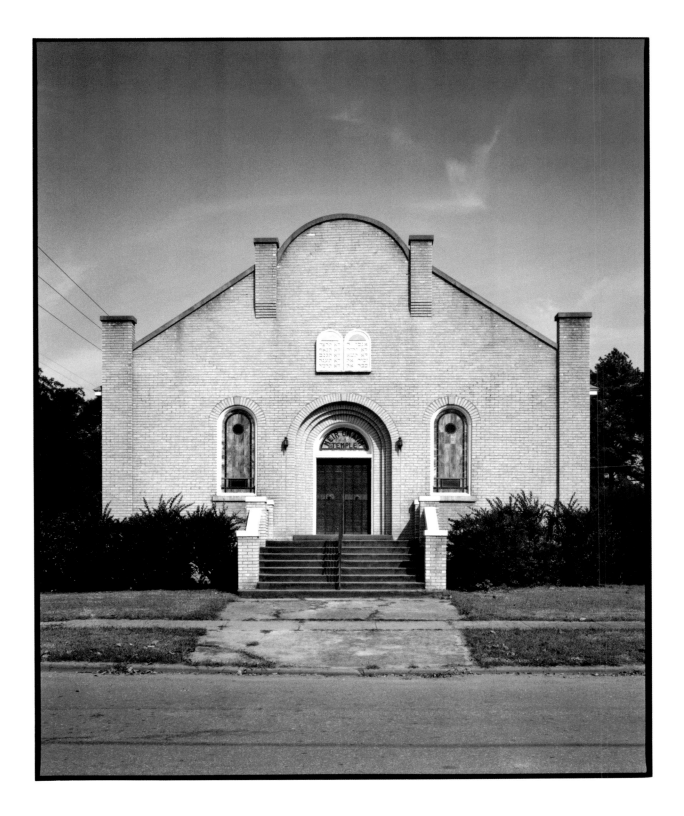

Temple Meir Chayim.
McGehee, Arkansas.
The temple, built in
1947, draws its dedicated
membership from several
small towns in southeast
Arkansas.

"And sometimes there are three congregants and sometimes there are two and sometimes there are four and sometimes a big crowd of six. But we go on and conduct the service just as if there were a hundred people there."

ZELDA MILLSTEIN AND MARTY NATHANSON, Natchez, Mississippi

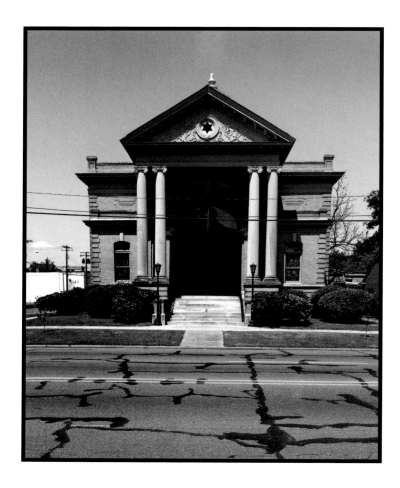

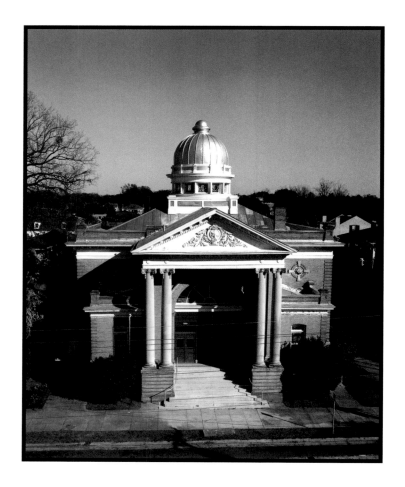

Hebrew Union Congregation. Greenville, Mississippi. By 1870 this thriving river port town had twenty-five to thirty Jewish families. Even though the Jewish community was diminished by the yellow-fever epidemic of 1878, it organized in 1880. The present Hebrew Union Temple was constructed in 1906. The synagogue's ark and Torah have been in use since 1882.

Temple B'nai Israel. Natchez, Mississippi. The first Jews came to Natchez in the late 1700s. The temple's architecture and grandeur reflect the importance and significance of the Natchez Jewish community during the early years of this century. Today, there are fewer than forty members in the congregation and the building has been designated a historic monument.

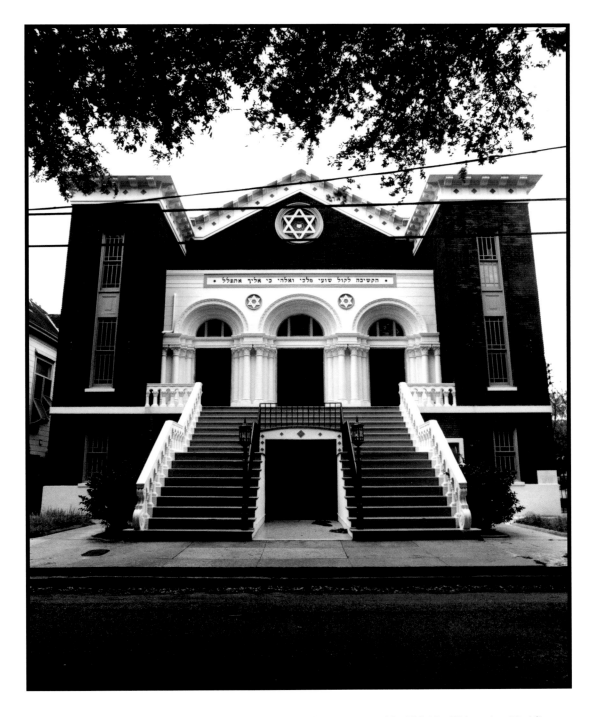

"Natchez was the center of Jewish life. We used to have people come in from Fayette, Waterproof, Jonesville, Ferriday, and Vidalia—all the surrounding areas. It was where everybody congregated and of course, particularly on the High Holidays, it was an old-fashioned family reunion."

JOE PASTERNACK, JR.
New Orleans, Louisiana

Anshe S'fard. New Orleans, Louisiana. The congregation was started in 1896 by Lithuanian Hasidic Jews who were practicing Sephardic rituals. The synagogue struggled with few members for twenty years or so and finally closed its doors in 1998.

"Jeanette Gorden was the sole Jewish member of Itawamba County.

She *was* the Jewish community. Once, as she was riding with one of the Baptist preachers

and he was driving too fast, she turned and asked him if he would like to be known

as the man who wiped out the entire Jewish population of Itawamba County!"

MARK PERLER, Tupelo, Mississippi

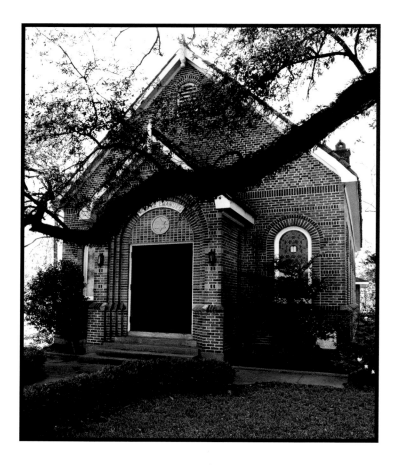

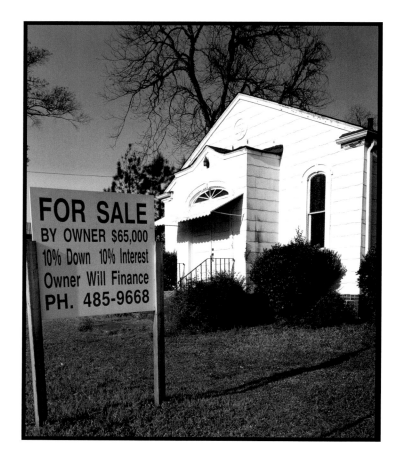

Temple Emanuel. Opelousas, Louisiana. Jews first came to
Opelousas in the mid-1800s. The present Temple Emanuel was built
in 1930 at the height of the town's Jewish population of about thirty
families. Services are no longer held in the synagogue, but each of
the five remaining families has a key to the building so they can go
there for meditation and private prayers. Some members now worship
in Temple Shalom in the nearby town of Lafayette twice a month
when a student rabbi is there to conduct services.

Ohel Jacob Synagogue. Meridian, Mississippi. The shrinking
Jewish community of Meridian put its Orthodox synagogue up for sale
when it was no longer used by the last members of the congregation.

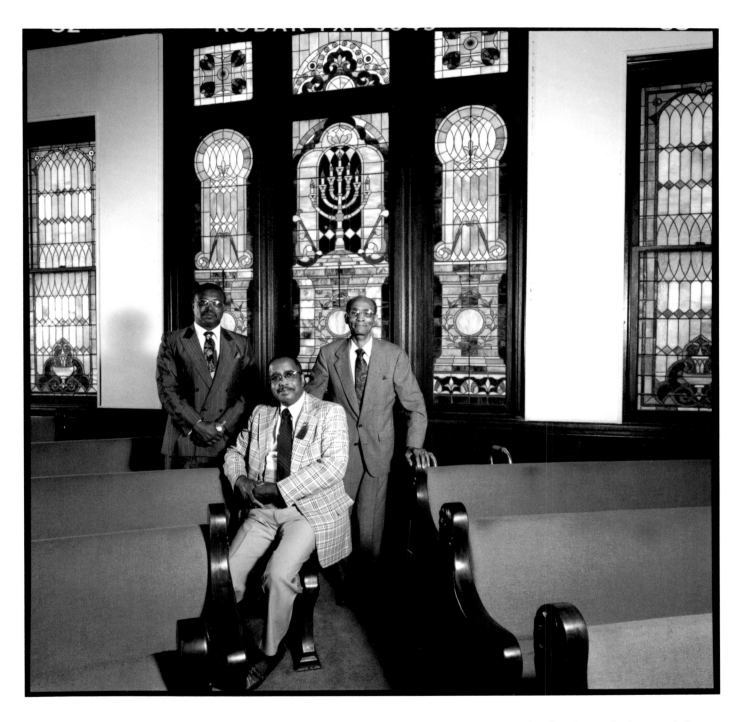

Elders of the Church. Pine Bluff, Arkansas. Many synagogues throughout the South now serve other functions and other populations. This former synagogue building of Congregation Anshe Emeth became a church when it was purchased by a Baptist congregation in 1968. Anshe Emeth, one of the first congregations in the state, received its charter from the state legislature in 1867.

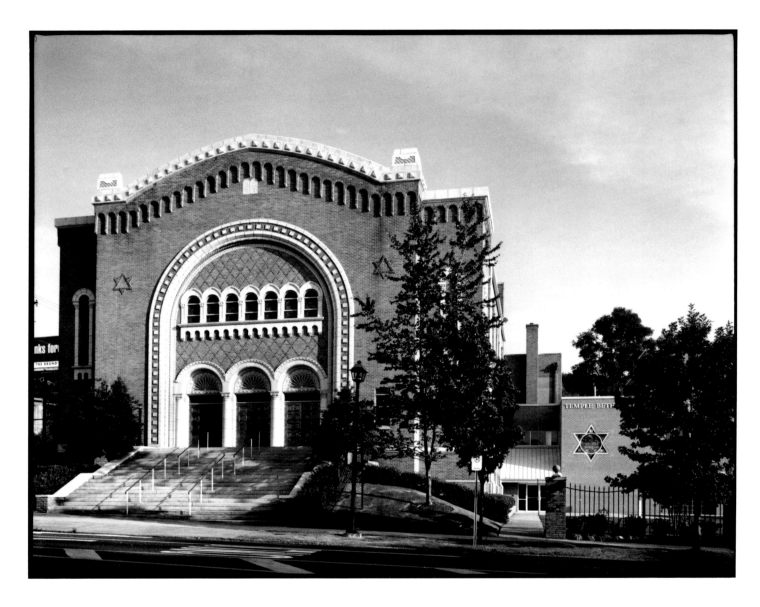

Temple Beth El. Birmingham, Alabama. This Conservative congregation was founded in 1907 by a group who wanted a more modern Orthodox approach than that of the Orthodox synagogue Knesseth Israel. The current building was erected in 1927 and has a membership of about 725 families. The temple was the site of an attempted bombing in 1958, but the case was never solved.

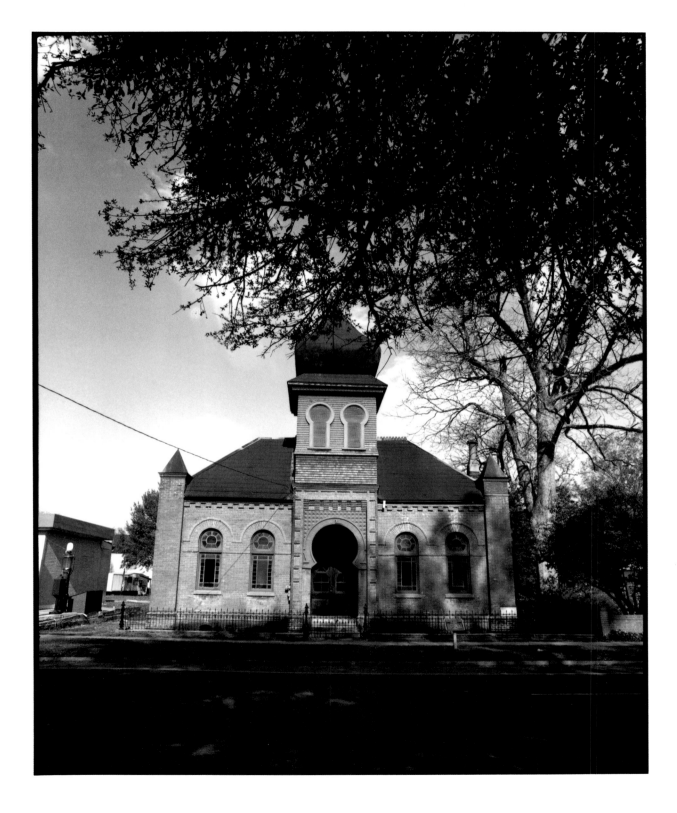

Temple Gemiluth Chessed. Port Gibson, Mississippi. The Port Gibson synagogue was organized in 1859 and included people from nearby Grand Gulf. The historic building, which has been designated as a national monument, was erected in 1892.

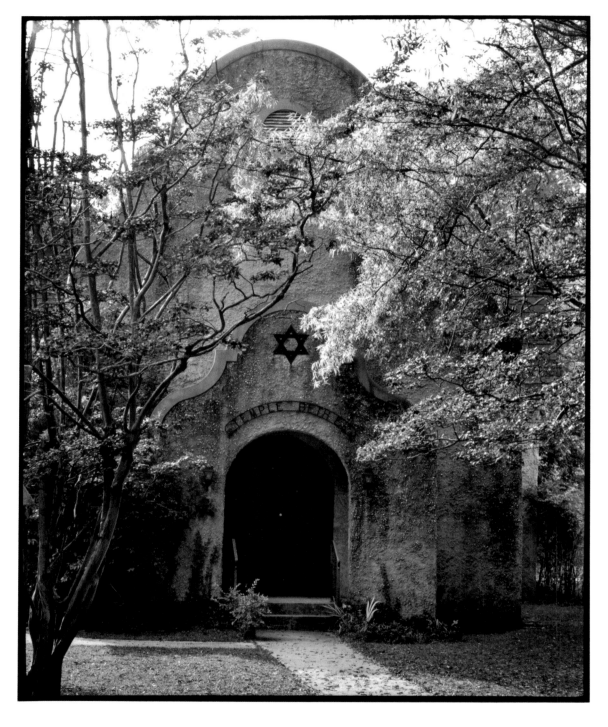

"The time was coming, and it was coming too fast, that there would be almost no one left to keep this temple functioning."

JAY B. LEHMANN
Natchez, Mississippi

Temple Beth El. Camden, South Carolina. In 1921, Camden's Hebrew Benevolent Association purchased an abandoned chapel and converted it to a temple. Today it is used only for High Holy Day services.

Formerly Congregation Bikur Cholim. Donaldsonville, Louisiana. The former synagogue of Congregation Bikur Cholim was built by French and German Jewish immigrants who traveled upriver from New Orleans to settle in Donaldsonville. When the congregation declined in numbers, the synagogue was eventually sold and became a local hardware store. A beautiful Jewish cemetery remains, which was watched over by the single remaining congregant, Gaston Hirsch, until his death in 1994.

Museum of the Southern Jewish Experience. Utica, Mississippi. Dedicated in 1989, this building, on the grounds of the Henry S. Jacobs Camp, is the main site of the museum, which operates satellite centers elsewhere in the region. Along with the galleries, museum offices, and storage, the building houses a synagogue sanctuary with architectural elements, furnishings, and Jewish artifacts from former congregations in the South.

"Shabbat shalom y'all. I want to welcome you to a unique experience, spending Shabbat with 150-plus Jews, Southern Jews at that."

LISA POLLACK, NFTY Southern president, addressing a group at a weekend retreat at the Henry S. Jacobs Camp, Utica, Mississippi

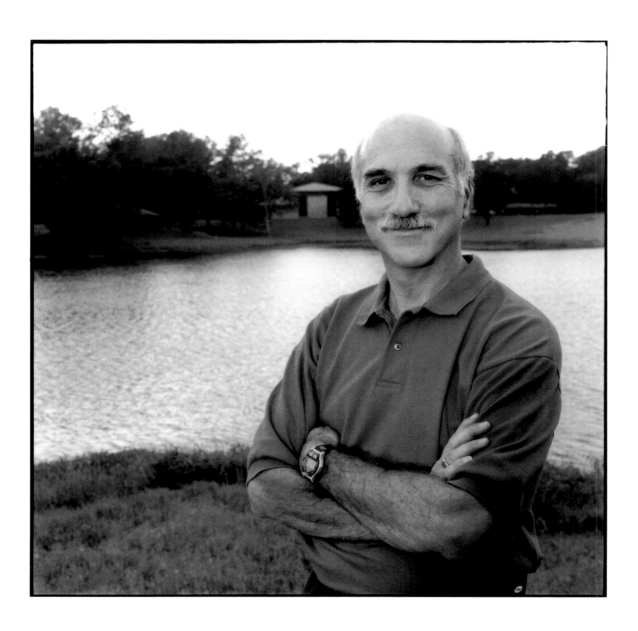

Macy B. Hart, President, Institute of Southern Jewish Life. A native of Winona, Mississippi, Macy has helped establish and direct institutions dedicated to the South and its Jewish population. Through his work in the creation of the Museum of the Southern Jewish Experience and most recently the Goldring-Woldenberg Institute of Southern Jewish Life, he has been instrumental in bringing the story of the Southern Jewish experience into focus.

During my second week in town, I got a phone call from the funeral home. An old woman had died who lived alone on one of the lakes outside Hot Springs. She didn't have any relatives in town, but a niece and a nephew were coming in from Memphis for the service and would take the body to Memphis. Would I do the service? No eulogy was needed. I agreed, and for a couple of days tried to find out whether any of the people I had met in Hot Springs knew the old woman. No luck. I prepared myself for the service and went to the funeral home, where I found a peculiar group of people assembled—not one Jewish-looking person or anyone that I had met, but lots of younger women and some men. I conducted a brief service, reciting the last chapter of Proverbs: 'A woman of valor who can find, for her price is far above rubies . . .' It is a reading that every rabbi uses for an elderly woman and sometimes even for a younger one.

"I concluded the service, said good-bye to the niece and the nephew, and drove back to town with the undertaker. He said, 'Rabbi, I thought you did an absolutely wonderful service, and when my time comes I hope that you will be able to officiate.' He was not Jewish.

"One day after the funeral, I met Dr. Benedict, a Jewish doctor originally from Germany, who said, 'I understand you did the funeral.' I said, 'Yes, Doctor, did you know the woman?' He said, 'Didn't you know? She was a madam out at the lake.'

"I reconsidered my words: 'A woman of valor who can find, for her price is far above rubies, the heart of a husband trusts in her, he has no lack of gain, she doeth him good and not evil, she gives a portion to her maidens, her household is clad in scarlet, her light never goes out at night'— it was all absolutely perfect. I was not able to use the passage for years; my wife, Sarah, broke down laughing whenever she heard it."

RABBI WALLI KAELTER

Rabbi of Congregation House of Israel, Hot Springs, Arkansas, 1945–49

Excerpted from his book, *From Danzig: An American Rabbi's Journey*

Written with Gordon Cohn

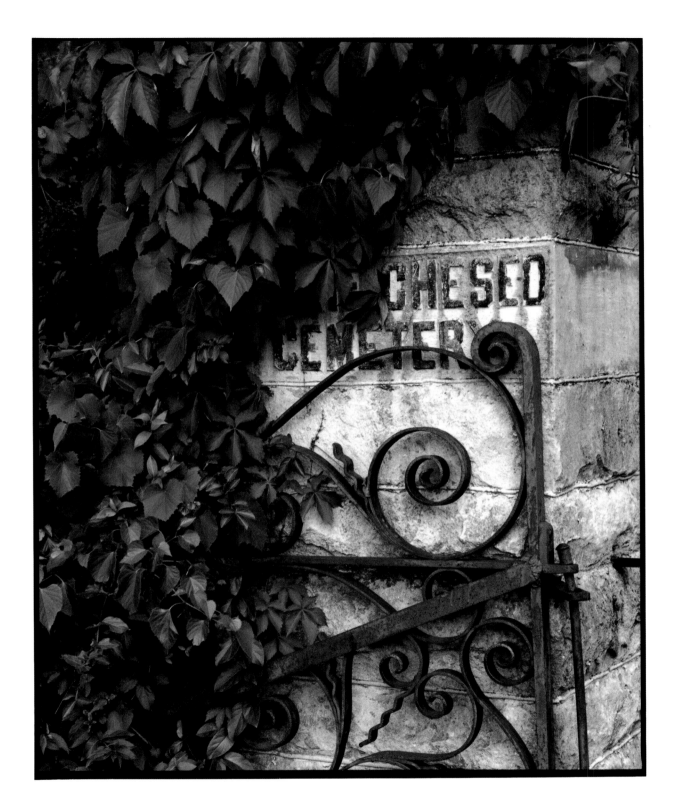

Anshe Chesed Cemetery. Vicksburg, Mississippi. Located in this community overlooking the banks of the Mississippi River, this historic cemetery dates from the late 1840s and has Civil War veterans among its dead.

In researching my book on the history of Arkansas Jewry, the earliest Jewish settler I found was Abraham Block , who had come to Washington, Arkansas, in the early 1820s from Richmond, Virginia. His wife was Frances "Fannie" Isaacs, daughter of Richmond, Virginia's first Jewish settler. The couple had eight children. While visiting the Southwest Arkansas Regional Archives at Old Washington, Arkansas, I found a 3 x 5 snapshot of a portrait of Abraham Block. I was told by the archivist that there reportedly had been three sets of large portraits of Abraham and his wife, Fannie, yet no one knew where they were. Through a series of unusual events, I discovered that one of the Block portraits was in Little Rock. Not only was it indeed Block's portrait, but hanging there beside it was the portrait of his wife, Fannie. They were large with gilded frames. The owner knew that Abraham Block had lived in Washington, Arkansas, but did not know that he and his family were Jewish. She didn't mind if I photographed the portraits, but she made me promise that I would not reveal her identity or tell anyone where the portraits were located.

In early 1988 I was asked to mount an exhibition based on my research. I called the owner and explained that the museum would like to borrow the portraits. She said she would never hear of it, that I had promised not to give away her name or address. Before she hung up, I told her that I would pray for her to have a change of heart and asked her to write down my name and phone number just in case.

After several months when the exhibition was nearly complete, I got a call from the owner. Urgently she said, "You can come and get the portraits of the Blocks." When I asked what had changed her mind, she said that as she walked down the stairs from her bedroom that morning and saw the portraits, she was thinking about them and my request. Quite suddenly, the portrait of Abraham Block fell to the floor. She was frightened and felt that it was not accidental that the portrait fell from the wall in front of her. "I don't know what caused it," she said, "but it made me change my mind about loaning the portraits and I want you to come and get them right away." After the exhibit closed, the Block portraits, which added such stature to the exhibit, went back to their unpublicized owners, where they remain.

CAROLYN GRAY·LEMASTER, Little Rock, Arkansas.

Author of *A Corner of the Tapestry:*

A History of the Jewish Experience in Arkansas, 1820s–1990s

University of Arkansas Press, 1994

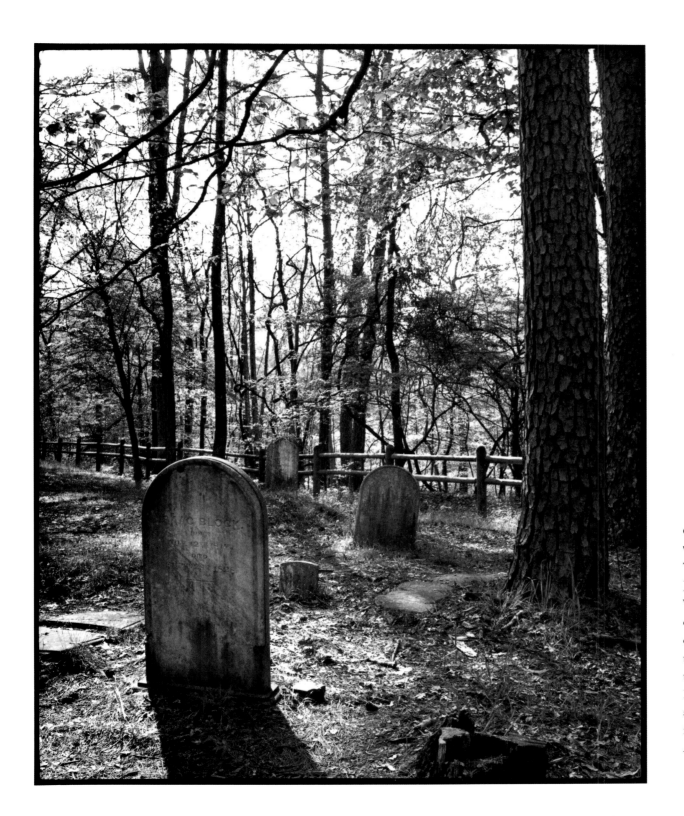

Grave of Isaac Block. Washington, Arkansas. There is no longer a Jewish community in Washington but the cemetery attests to the original Jewish roots in the state. Isaac Block is the son of Abraham Block, who is generally acknowledged to be the first Jewish settler in Arkansas.

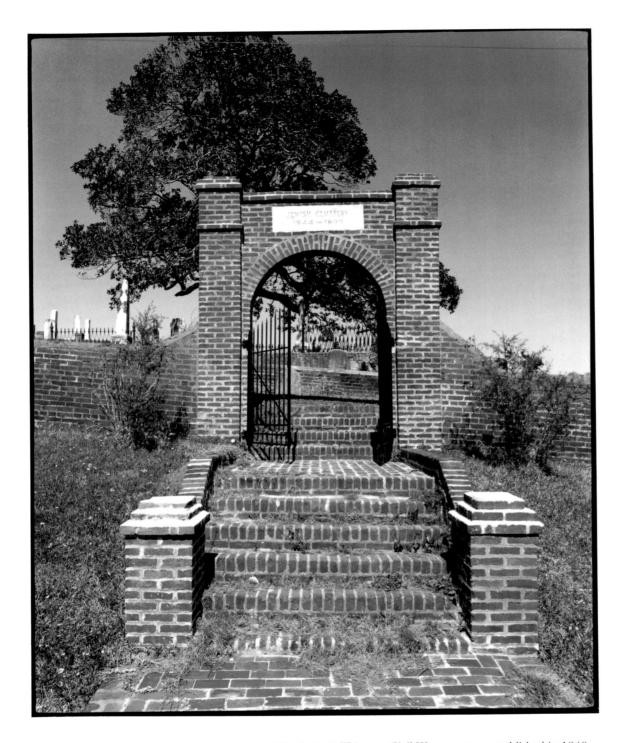

Gerry: In a Jewish funeral the body has to be wrapped in a certain way. The local funeral directors did not know how to take care of it.

Abe: So when starting, the rabbi would do a prayer, 'Excuse us, O Lord, for we know not what we do,' and then we would proceed with the directions that he had brought with him.

GERRY BARKOVITZ
and her brother-in-law,
ABE BARKOVITZ
Hayti, Missouri

Jewish Cemetery Entrance Gate. Natchez, Mississippi. This pre–Civil War cemetery, established in 1840, has the grave of the only Civil War Jewish casualty from Natchez, Rosalie Beekman.

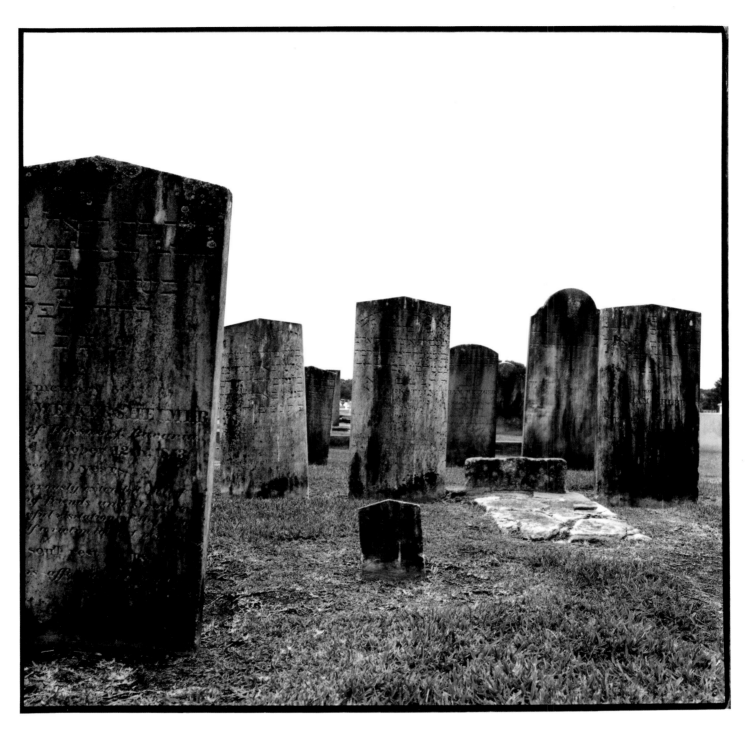

The Old Church Street Graveyard. Mobile, Alabama. Mobile has had a Jewish community for over two hundred years. Some of its first Jewish citizens are buried in this cemetery.

"My great-grandfathers were in the Civil War. I am the fifth generation. It is not unusual here because so many of the older families originally settled in little Southern towns. None of us really understands how our family got to Port Gibson instead of Natchez, but that is where they were and they founded the temple there. Then they came to Natchez."

ELAINE LEHMANN, Natchez, Mississippi

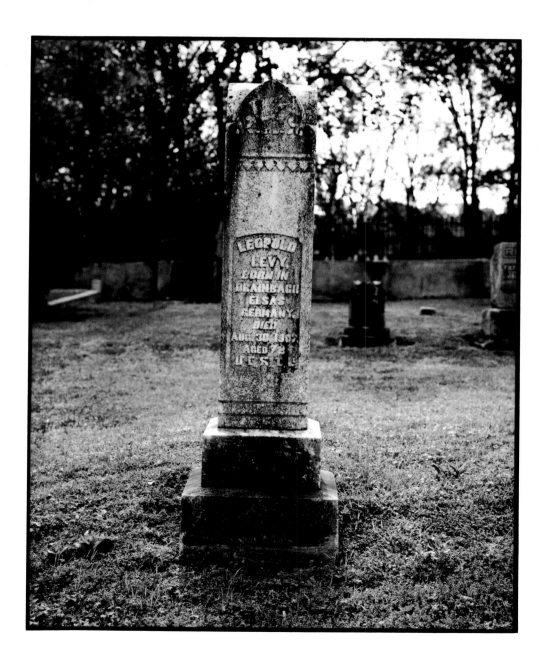

Jewish Grave Marker. Port Gibson, Mississippi. The upside-down and backward Hebrew inscription on the tombstone poignantly illustrates that there were no Hebrew-speaking gravestone cutters in this part of the country. The cemetery was established in 1871.

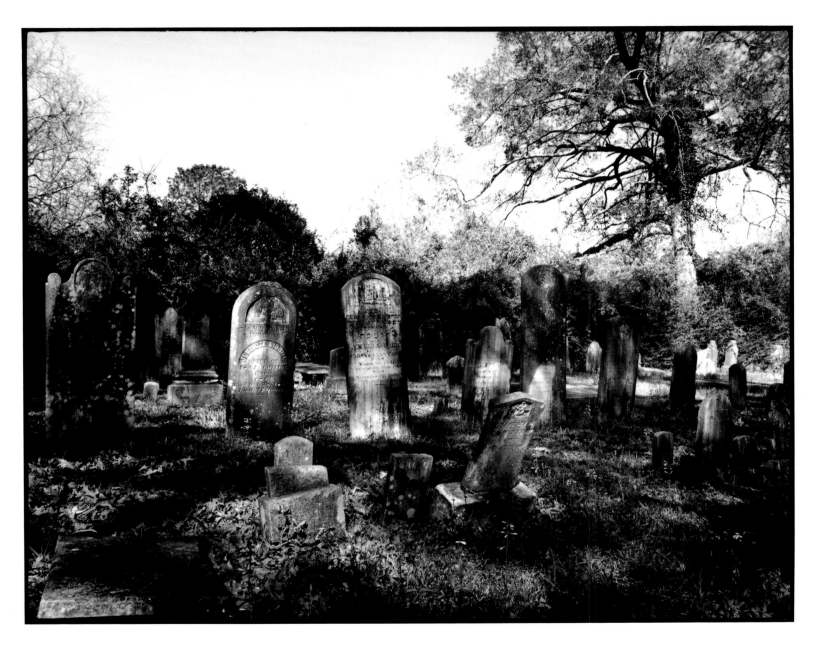

Jewish Cemetery. Woodville, Mississippi. Cemeteries are both the first and the last signs of a Jewish community. The first Jewish cemetery in Mississippi was established by Jacob Cohen and Jacob Schwarz when they purchased a small piece of land in Woodville for fifty dollars in 1849, in which they buried their friend and fellow peddler Henry Burgance.

E. H. F.

on board U.S.S. *New Hampshire,*

Close to Vera Cruz, Mexico,

April 21, 1914.

Dear Poppa:

Don't be afraid if I get killed, For the old saying, "Rather die a hero than live a coward," will land at Vera Cruz in about Four hours, They take so many men off each ship to be in the landing party, I am one of them, The U.S.S. *Florida* sent a battalion ashore this morning, Four killed, twenty wounded, There are five battle ships with us, We are going as fast as we can, about seventeen knots, Poppa this is a very sad hour, Although I am not a man, I would rather die a man, We expect to land about Two o'clock in the morning, They have about four to our one along the sea coast, Every man has a tag tied around his neck with his name, ship and company rate on same, Poppa, I only hope I live through this and all of you are living when I come home,

Your loving son,

Esau

(Text of letter printed on gravestone in Jewish cemetery. Mobile, Alabama.)

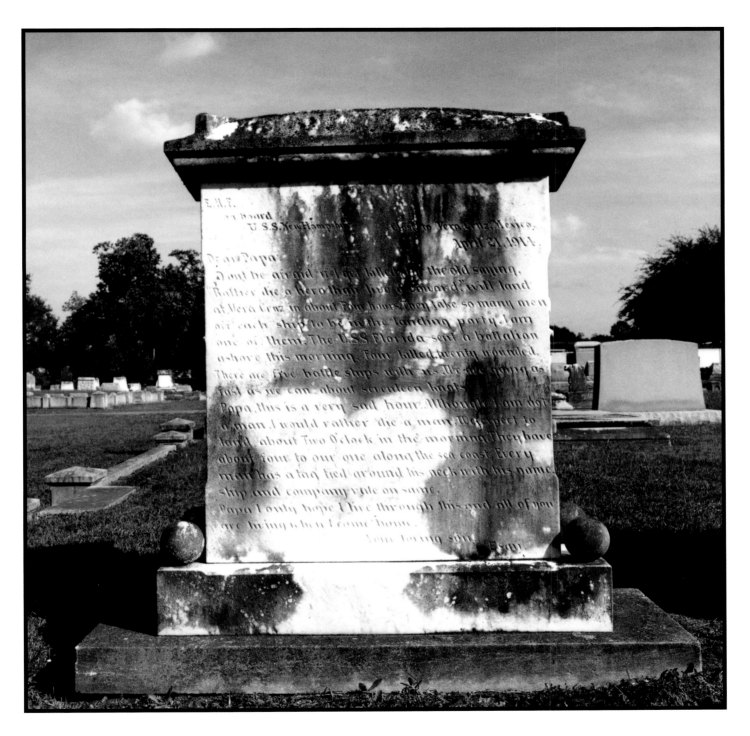

Gravestone with Letter, "The Old Magnolia Cemetery." Mobile, Alabama. Letter written by a son to his father just before he was killed in the Spanish-American War.

Gloria and Kalman Shwarts. Montgomery, Alabama. The Shwartses, longtime residents of Montgomery, are holding portraits of Gloria's great-grandparents, Jacob Weil and Getta Waterman Weil. Gloria's family has been in Montgomery since the 1830s.

"My phone rings one night and after I answer it there is a slight hesitation before the voice on the other line begins, with no introduction or name, 'Who is that fellow in the Israeli army with a patch on his eye?' After I answered, the person just hung up."

ROBERT GARTENBERG
Hot Springs, Arkansas

"First thing you're asked when you come to Montgomery: 'Are you an Alabama or an Auburn [football] fan?' And the next question is 'Where do you go to church?'"

HARRY LEBOVITZ
Montgomery, Alabama

Southern Ties

"People said you can't stay in Mobile, Alabama, and write for the music and film industry, and they were right. But I was too stupid to believe it, so I did it anyway."

MILTON BROWN, Mobile, Alabama

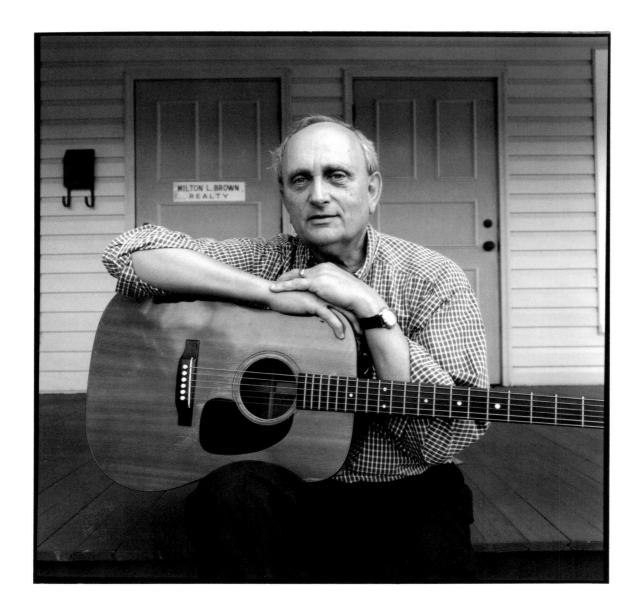

Country and Western Songwriter. Mobile, Alabama. Milton Brown has written songs for well-known movies and screenplays, but he prefers doing it from his home in Mobile, rather than in Hollywood or Nashville.

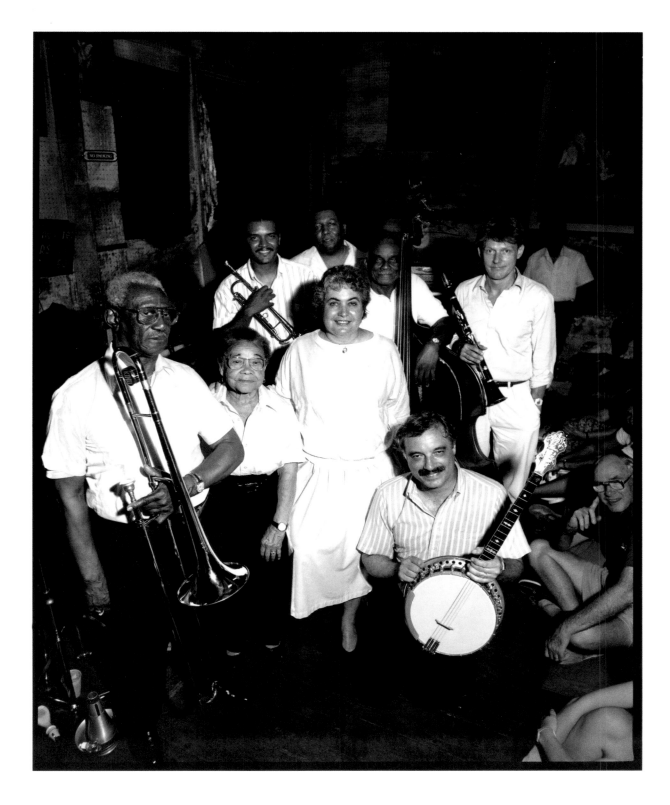

Sandra Jaffee and the Preservation Hall Band. New Orleans, Louisiana. Sandra Jaffee and her late husband Alan founded Preservation Hall in the early 1960s to showcase the South's legendary musical heritage. Located in the heart of the French Quarter, it stands as an important landmark for Dixieland Jazz.

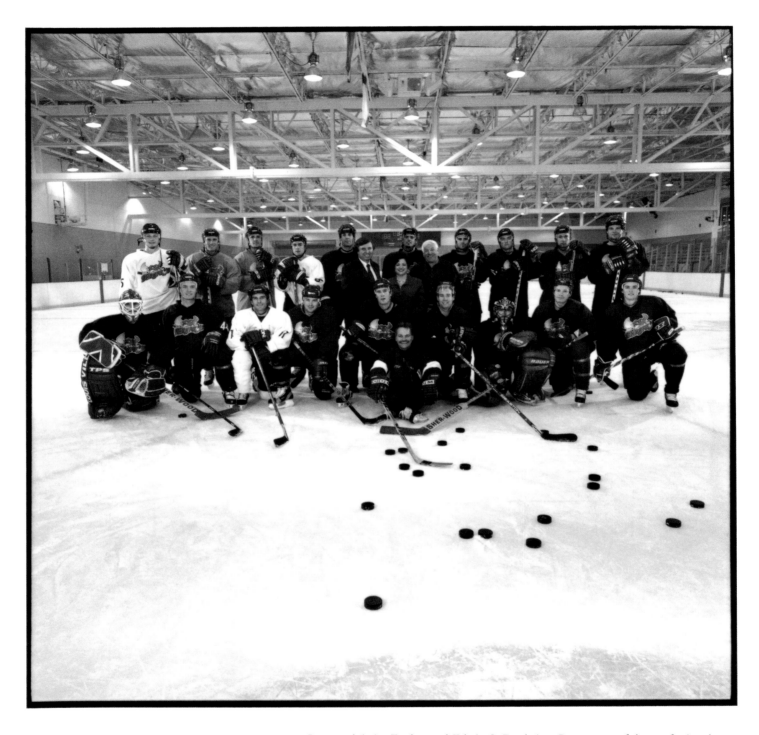

The Stingrays. North Charleston, South Carolina. Jerry and Anita Zucker and Edwin S. Pearlstine, Jr., owners of the professional hockey team, appear at the Carolina Ice Palace with the players, trainers, and coach during practice.

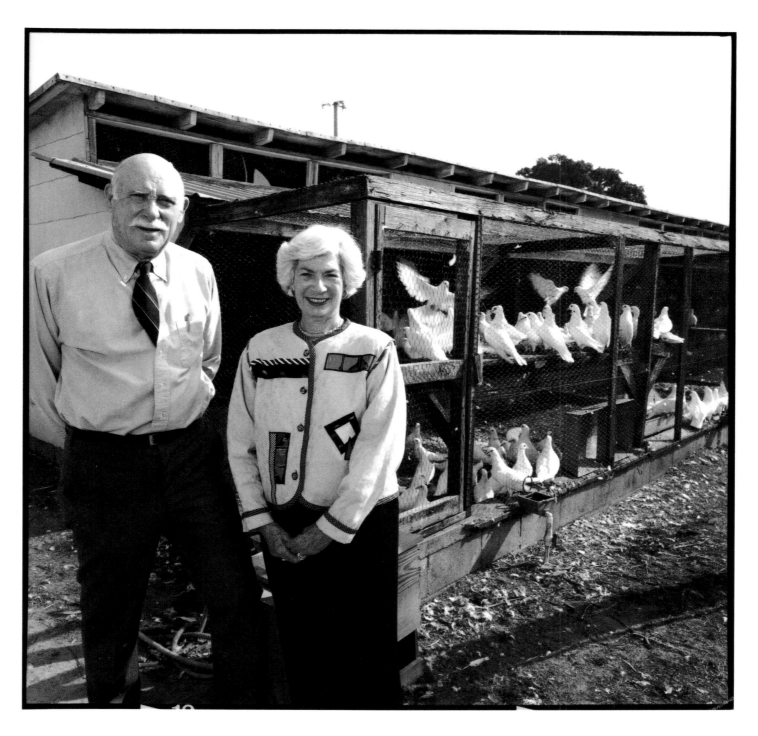

Palmetto Pigeon Plant. Sumter, South Carolina. Patty Levi Barnett and her twin brother, Wendell M. Levi, Jr., own the largest squab farm in the world, which was founded in 1923 by their father and his partner.

"When I started the paper in 1990, it was sixteen pages. Everyone asked me if there was enough news in Alabama's Jewish community to fill that much space. Today the paper is forty to sixty pages, and there's far too much good story material out there. Running a Jewish newspaper in the Deep South brings me many very unusual stories, the likes of which you won't see in a place like New York or Los Angeles. It's Jewish news with a Southern accent."

LARRY BROOK, Founder, editor, and publisher of *Deep South Jewish Voice*, Birmingham, Alabama

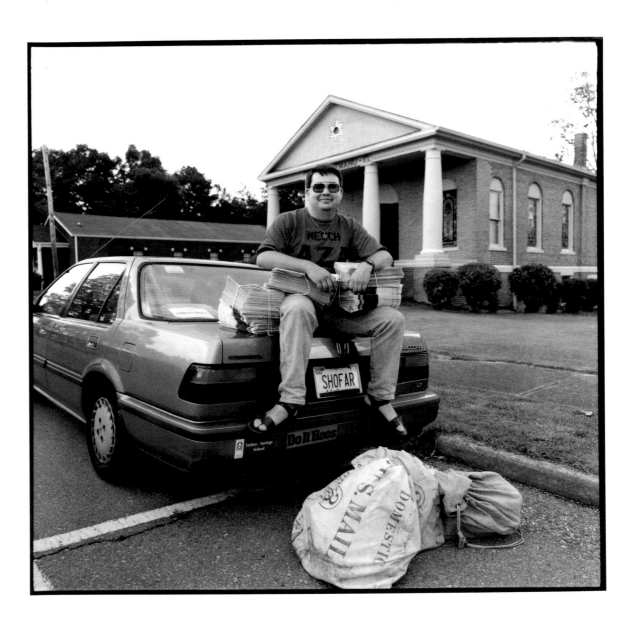

Larry Brook, *Deep South Jewish Voice*. Birmingham, Alabama.

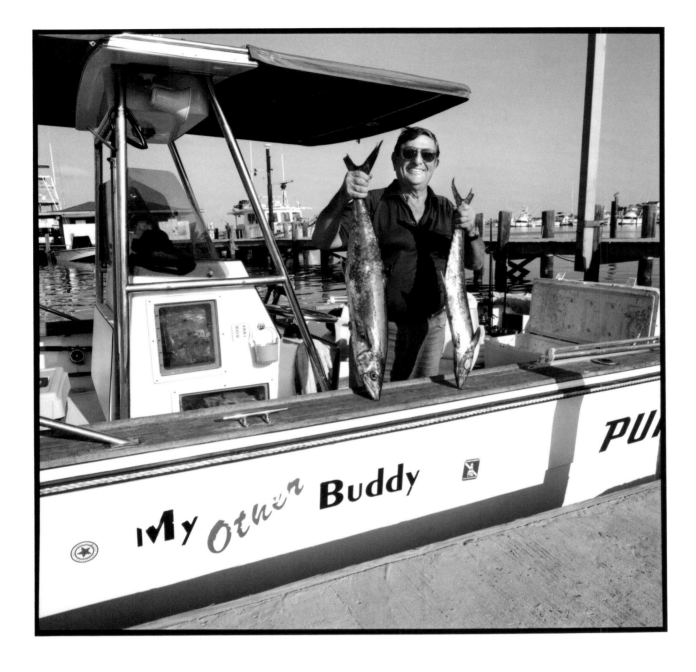

Joe Schwartz.
Dauphin Island,
Alabama.

"My father used to call this area "God's Little Acre" because you don't have to starve down here.
All you had to do was to have a fishing pole. Anytime of the year you can go out and catch
seafood to eat or crabs."

BARBARA EDISEN, Morgan City, Louisiana

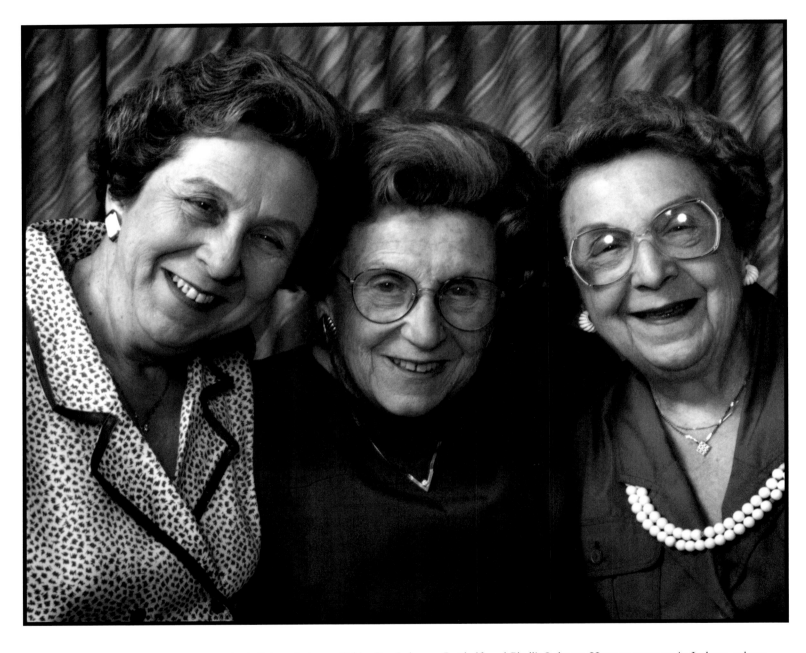

The Lehman Sisters. Jackson, Mississippi. Celeste Lehman Orkin, Bea Lehman Gotthelf, and Phyllis Lehman Herman grew up in Jackson, where they have contributed significantly to Jewish and non-Jewish community activities. Celeste Orkin is one of the founders of the Henry S. Jacobs Camp.

"When I graduated from high school, I wanted to go to one of the Eastern colleges. Not one would accept me. I had the highest grades in my class. They would not accept me because I was Jewish. Their Jewish quota was filled."

PHYLLIS LEHMAN HERMAN, Jackson, Mississippi

"The reason I became involved in organizing the Henry S. Jacobs Camp [Utica, Mississippi] is that a friend of ours' daughter went to a camp. She had gone three years and was old enough to be a leader. She applied for a job as a counselor, and they wouldn't give it to her because she was Jewish. She could go to the camp, but she could not be a counselor. That made me so mad. That is when I decided to become involved."

CELESTE LEHMAN ORKIN, Jackson, Mississippi

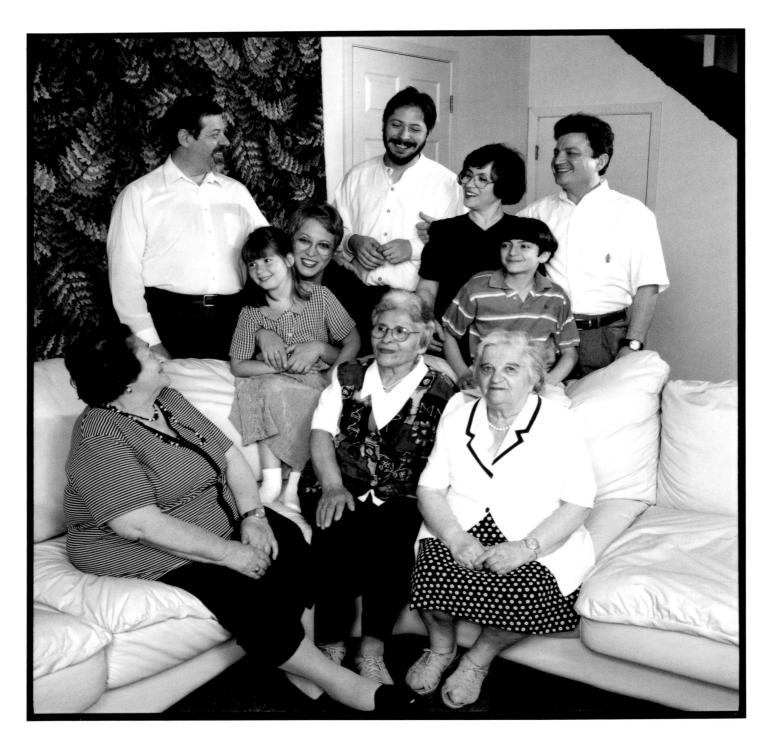

The Rickelman Family. Birmingham, Alabama. Birmingham is the new home of the Rickelman family, who emigrated from Russia. The family holds on to traditions from their native land while becoming Southern Jews in their new homeland.

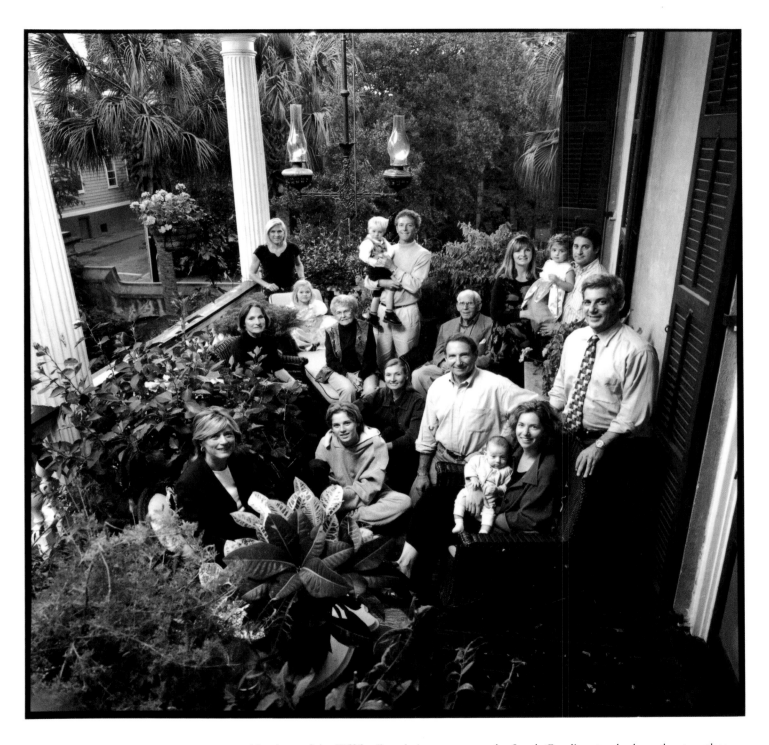

Ziff Family. Charleston, South Carolina. Members of the Ziff family, relative newcomers by South Carolina standards, gather together on the piazza of Stephen and Julie Ziff's house on historic Legare Street.

127

"We have Temple every Friday night at six o'clock. It's a fabulous idea, because kids can come before they go to football games."

VIVIAN LEVINGSTON, Cleveland, Mississippi

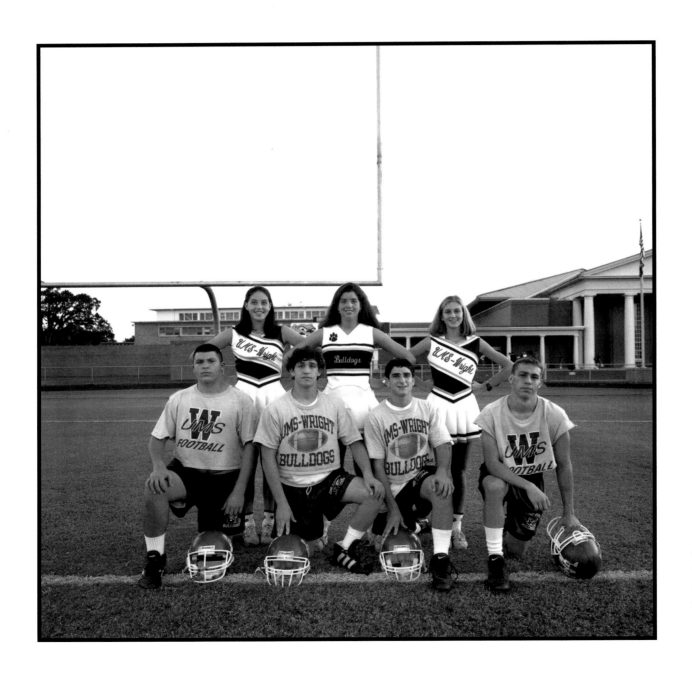

Jewish High School
Cheerleaders and
Football Players.
Mobile, Alabama.

From Generation to Generation. Mobile, Alabama. Joy Grodnick poses in front of the family picture wall, which celebrates the generations of her own family who have been active and committed members of the Mobile Jewish community. Joy's three daughters are fifth-generation Mobile Jews.

"When Clay finally decided to marry me there was only my mother left. So Clay said to me one night, 'I think I ought to take your mother out to dinner and ask her how she feels about us getting married.' He took her out and they had a couple of drinks and he told her that he wanted to marry me. 'What do you think about it? Do you approve?' She said, 'I have something to ask you, but I don't think that I can ask you.' So, they had a couple of more drinks. She finally said, 'Are you circumcised?' He said, 'Yes. Is that all right?' She said, 'Fine. Y'all can get married.'"

BARBARA EDISON, Morgan City, Louisiana

Mrs. Rose Rotenstreich. Birmingham, Alabama. Rose Rotenstreich, matriarch of the family, was a passionate storyteller. Surrounded by a brood of children, grandchildren, and great-grandchildren in Birmingham, where she grew up, Mrs. Rotenstreich embodied the Southern Jewish experience. In 1922 she was honored by her male peers as "Miss YMHA" (Young Men's Hebrew Association), for which she was given this cup. She passed away some time after this picture was taken.

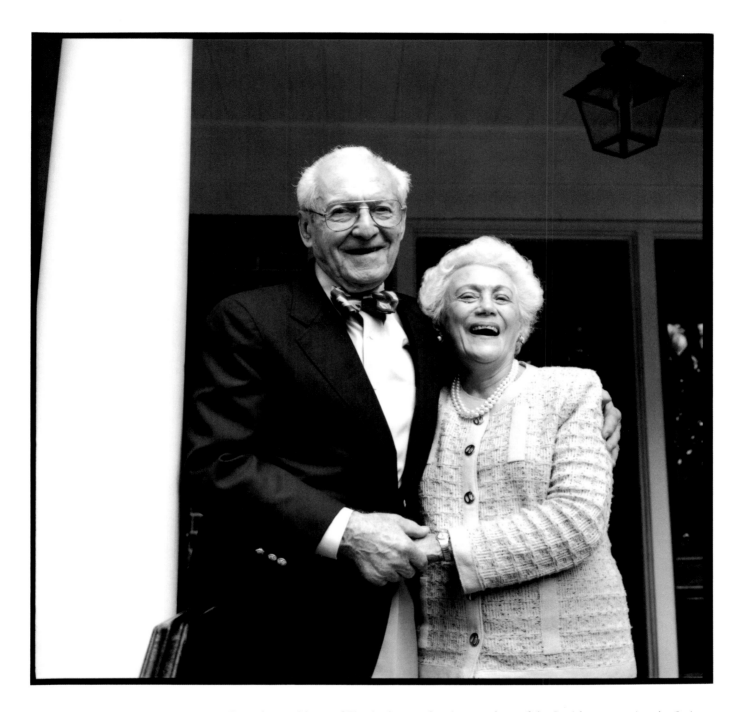

The Steins. Birmingham, Alabama. Longtime residents of Birmingham and active members of the Jewish community, the Steins have lived here for most of their sixty years of married life.

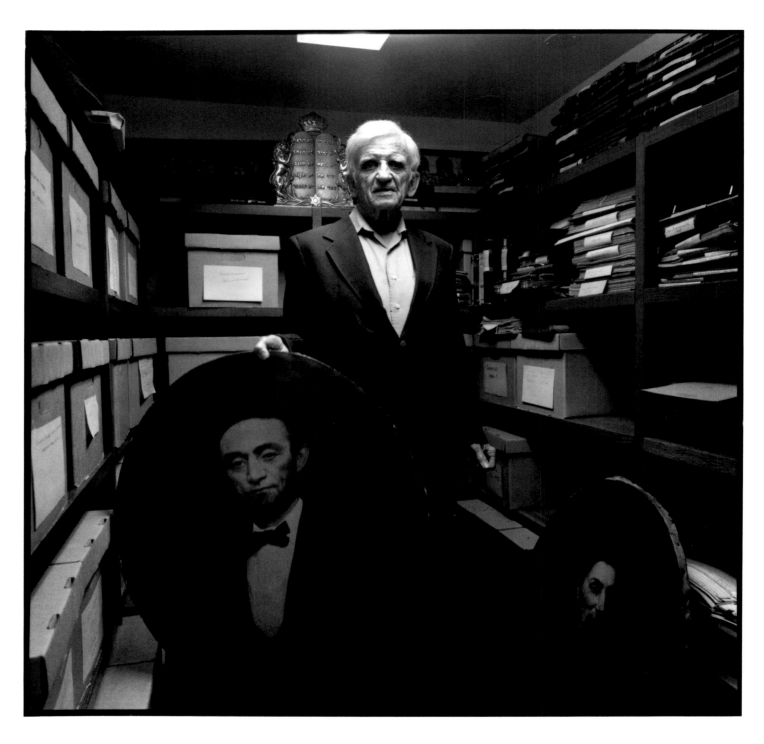

Bob Zeitz, Springhill Avenue Temple. Mobile, Alabama. Bob Zeitz created and oversees the archives of Springhill Avenue Temple, which was founded to preserve the over 150-year history of the congregation and Mobile's Jewish community.

"A lot of Northern Jews when they hear a Southern accent, they don't really believe
you are Jewish. It's the silliest thing."

JIMMY SABEL, Montgomery, Alabama

**David Drexler. Wynne,
Arkansas.** One of the last
Jews in the community, David
Drexler holds a photograph
of his father, Meyer Drexler,
who came to Arkansas and
established the St. Louis Store,
a successful dry-goods business.
The elder helped establish,
in 1915, an Orthodox
congregation, Ahavah Achim.
Services were held on the
second floor of Drexler's
store for about thirty families
from Wynne and nearby
communities.

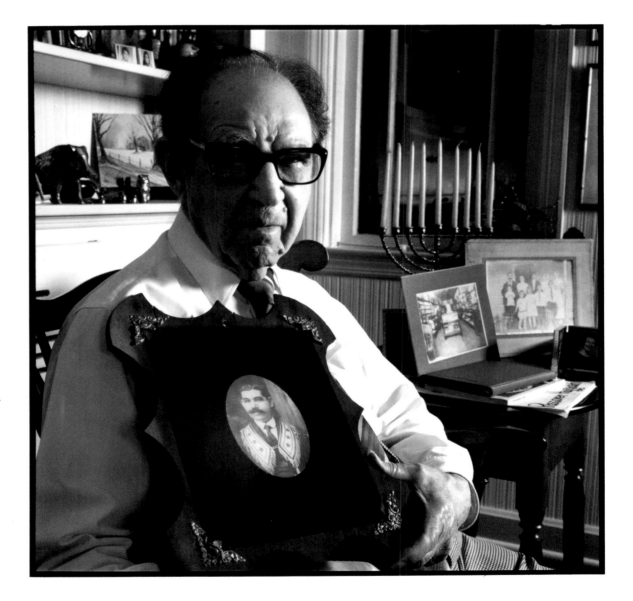

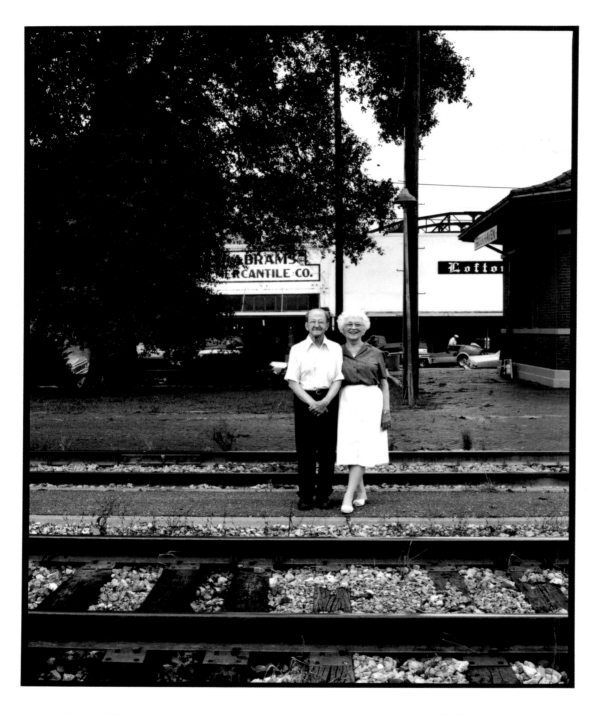

"Daddy died in the heart of the Depression and we were loaded up with debt. I promised my daddy I would pay his debts. That is what he told me to do. The day that I paid the last payment on the store building is when I told Wilma we were going to get married."

CLIFF ABRAMS
Brookhaven, Mississippi

"The next day after we married it came the darndest snow you ever saw in your life. Right here in Brookhaven, Mississippi. I mean it was knee deep and it stayed on the ground for weeks. One of his customers said 'something unusual is bound to happen because Cliff Abrams got married.'"

WILMA ABRAMS
Brookhaven, Mississippi
Married January 21, 1940

Cliff and Wilma Abrams. Brookhaven, Mississippi. Growing up in Brookhaven, Cliff Abrams saw a tremendous change in his eighty-seven years. He and his wife lived in the house where Cliff was born in the early 1900s and operated a hardware store that was started by Cliff's father and uncle. Cliff died in 2000.

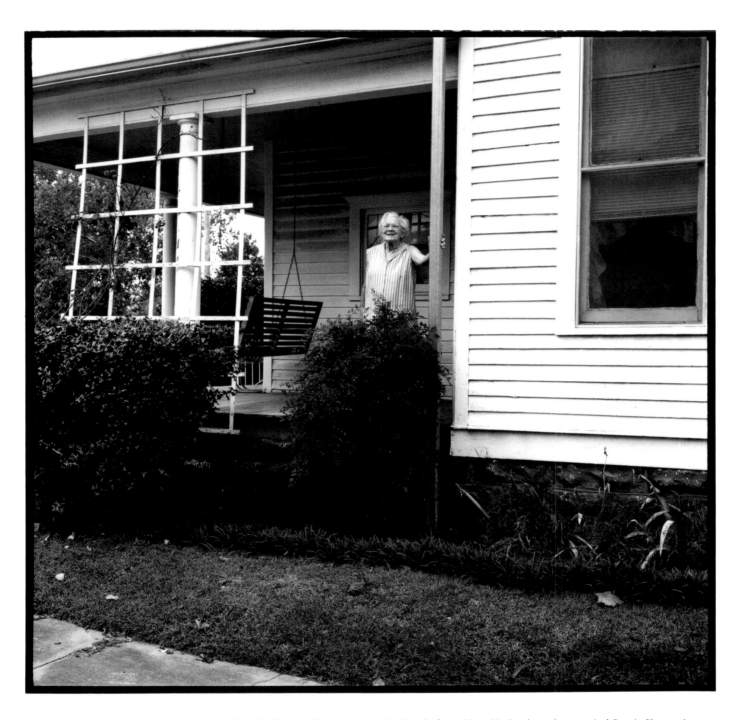

Sara Kasten. Fort Smith, Arkansas. Born in Russia, Sara came to the South from New York when she married Louis Kasten in 1919. Fort Smith has been her home ever since. Louis helped organize an Orthodox congregation, B'nai Israel, where they were both active until its demise and merger into the Reform group in the 1930s. Sara is the only living member of that earlier Orthodox group.

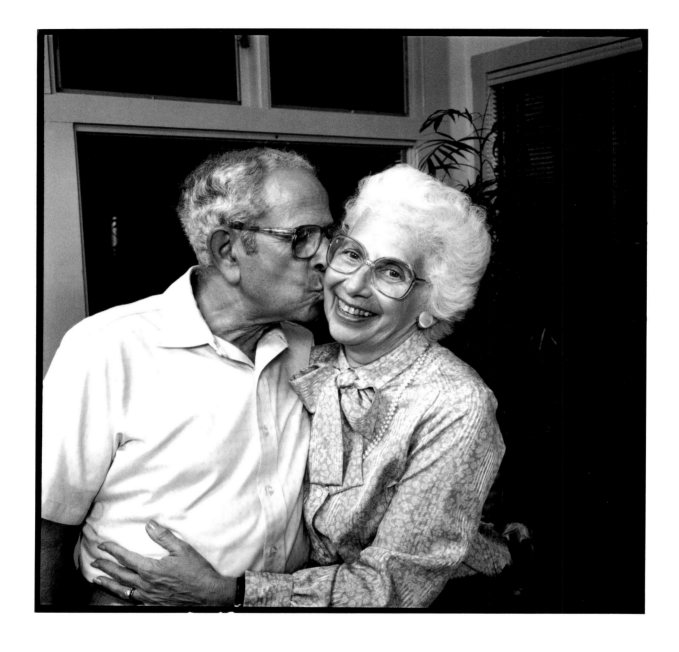

Joe and Suzi Rosenzweig, Hot Springs, Arkansas. The Rosenzweigs are dedicated members of the Arkansas Jewish community. Joe's Lithuanian father came to the area in 1892 and peddled throughout southeast Arkansas until he opened a dry-goods store in Lake Village, Arkansas.

"My father's mother was born in the South, a true Southerner. Her religion was that she didn't eat bacon on Saturday."

SUZI ROSENZWEIG, Hot Springs, Arkansas

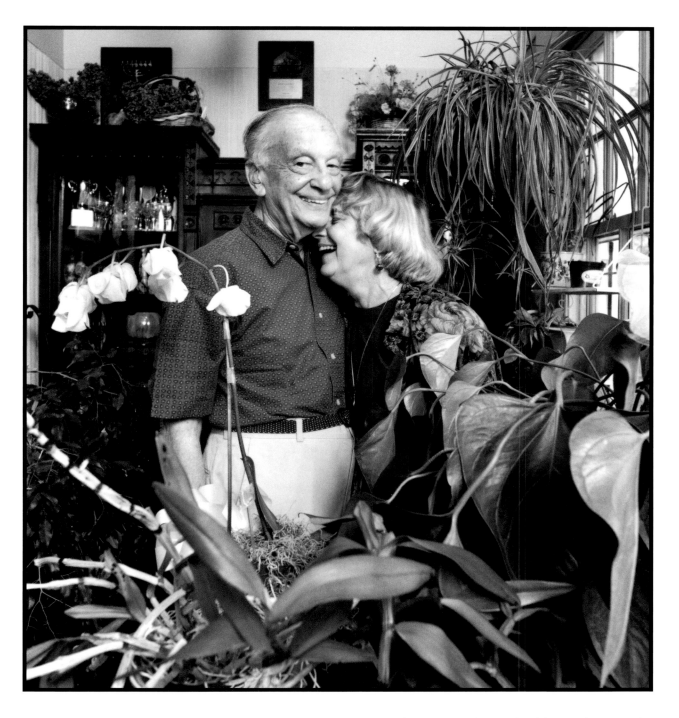

Mr. and Mrs. Mayer Newfield. Birmingham, Alabama. It is through family stories that much of the Southern Jewish legacy is preserved. Mayer is recognized as one of Birmingham's finest storytellers. One of his favorite subjects is his own family's long history in Birmingham's Jewish community.

"When people ask me what the Southern Jewish community is like,

I say it's one big extended family."

MARK PERLER, Tupelo, Mississippi

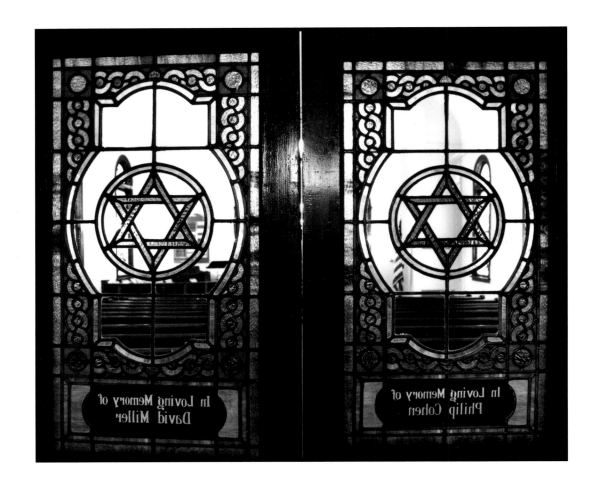